IMAGES
of America

THE MANHATTAN PROJECT
AT HANFORD SITE

The Hanford Site, selected as part of the supersecret World War II Manhattan Project, was 670 square miles of isolated land in the desert of southeastern Washington. (Courtesy of US Department of Energy Declassified Document Retrieval System.)

ON THE COVER: The B-17G *Day's Pay* is pictured at the Hanford Airport on July 23, 1944. (Courtesy of US Department of Energy Declassified Document Retrieval System.)

IMAGES
of America

THE MANHATTAN PROJECT
AT HANFORD SITE

Elizabeth Toomey

ARCADIA
PUBLISHING

Published by Arcadia Publishing
Charleston, South Carolina

Printed in the United States of America

Library of Congress Control Number: 2015939362

For all general information, please contact Arcadia Publishing:
Telephone 843-853-2070
Fax 843-853-0044
E-mail sales@arcadiapublishing.com
For customer service and orders:
Toll-Free 1-888-313-2665

Visit us on the Internet at www.arcadiapublishing.com

To my mother, Diana, who brought World War II and the occupation to life through her stories as a Japanese linguist for the US Army Intelligence

CONTENTS

ACKNOWLEDGMENTS

An early love of World War II history that was fostered by my parents, Paul and Diana, who served as Japanese linguists in the US Army Intelligence during the war and the Occupation of Japan, and a career that led to managing the REACH museum project, resulted in the writing of this book. The REACH opened on July 4, 2014, dedicated to sharing our community's stories. One of those stories was our historic role in the secret Manhattan Project. Site W, as Hanford was known, developed plutonium for the "Fat Man" bomb, which led to Japan's surrender. It was a turning point in world history and one of the most incredible stories of all time. Hanford was critical to the war effort, encompassing massive construction, patriotism, secrecy, urgency, research, and innovation that began the Atomic Age. The narrative herein is based on publicly available historic research conducted by Pacific Northwest National Laboratory, HistoryLink.org, Port of Pasco, University of Washington, Boeing, ALCOA, US Department of Energy (and its predecessor agencies), Bureau of Reclamation, Bonneville Power Administration, Mick Qualls, Confederated Tribes of the Umatilla Indian Reservation, Franklin County Historical Society, Kadlec Hospital, Wanapum Band, Atomic Heritage Foundation, and other open source materials available on the web.

This publication is intended to serve as a companion piece to the REACH's exhibit on the Manhattan Project-Hanford Engineer Works. Special thanks to my husband, Jim, and kids Chris, Megan, and Shannon for supporting my weekend "job" writing this book; Dan Ostergaard for assistance with photograph identification; Nancy Bowers, REACH volunteer, for extraordinary editing and selection of photographs; Dianna Millsap at the REACH for project management and coordination, selection of photographs, and moral support; not to mention the rest of the REACH staff who put up with "one more project" to help in our storytelling efforts. Catherine Johnson-Pearsall (CJP) allowed access to her private collection of photographs taken by Robley Johnson, the official Hanford photographer during the Manhattan Project and beyond.

Unless otherwise noted, the photographs used in this publication are from the public domain, which to the best of my knowledge either have no registered copyright or the copyright has expired. Quotes from Robley Johnson are from an interview by Ted Van Arsdol, entitled "Robley Johnson Remembers," 1991. We believe this story will fascinate and inspire you as much as it has inspired us.

INTRODUCTION

There are very few moments in US history that have captured the hearts and minds of American citizens more than World War II. Studying "the Good War" reveals to those who came later that it was at once both frightening and exciting. There was an important role for everyone to play, whether it was to serve in the military, work in a factory, grow a victory garden, volunteer at a USO hall, buy a war bond, or even embrace rationing. Americans exemplified patriotism in every aspect of their lives. And for some, it meant working on the most secret project in American history.

Early in 1939, the world's scientific community discovered that German physicists had learned the secrets of splitting a uranium atom. Fears soon spread over the possibility of Nazi scientists utilizing that energy to produce a bomb capable of unspeakable destruction. Scientists Albert Einstein, who fled Nazi persecution, and Enrico Fermi, a physicist who left Fascist Italy for America, encouraged the United States to begin atomic research. They agreed that the president must be informed of the dangers of atomic technology in the hands of the Axis powers. Fermi traveled to Washington, DC, in March to express his concerns to government officials. Leó Szilárd, who had left Hungary, wrote a letter to President Roosevelt that was signed by Albert Einstein urging the development of an atomic research program later that year. Roosevelt saw neither the necessity nor the utility for such a project but agreed to proceed slowly.

In late 1941, the American effort to design and build an atomic bomb received its code name, the Manhattan Project. Secrecy was paramount. Neither the Germans nor the Japanese could learn of the project. President Roosevelt and Winston Churchill also agreed that Joseph Stalin would be kept in the dark. Consequently, there was no public awareness or debate. Only a small privileged cadre of inner scientists and officials knew about the atomic bomb's development.

The Manhattan Project operated like a large construction company. It purchased and prepared sites, let contracts, hired personnel and subcontractors, built and maintained housing and service facilities, placed orders for materials, developed administrative and accounting procedures, and established communications networks. By the end of the war, $2.2 billion ($26 billion in today's dollars) had been spent. What made the Manhattan Project unlike other companies performing similar functions was that, because of the necessity of moving quickly, it invested hundreds of millions of dollars in unproven and hitherto unknown processes and did so entirely in secret.

The Manhattan Project might have been a massive construction project, but it was a military operation from the get-go. It was funded by president and commander in chief Franklin D. Roosevelt, led by Secretary of War Henry Stimson, and administered by Gen. Leslie R. Groves of the US Army Corps of Engineers. It took scientist J. Robert Oppenheimer's "galaxy of luminaries" to solve the science of atomic bombs; it took America's leading industrial powerhouses to engineer the solutions; it took career bureaucrats at all levels of government to remove the obstacles and smooth the path forward. But it took a uniquely military perspective on what General Groves called the "exigencies of war"—the understanding that a Fascist world was a very real possibility and that the development of overwhelming, coercive power was the only way to guarantee quick and decisive victory to get the job done. The Manhattan Project took the United States from theoretical physics all the way to a working atomic bomb in under three years' time.

Both the size and scope of the Manhattan Project were unprecedented, necessitating previously unheard-of cooperation between government, industry, and scientists at the frontier of nuclear physics. In 1941, the MAUD Report (Military Application of Uranium Detonation), drafted by British physicist James Chadwick, concluded that the creation of an atomic bomb was not only feasible, but urgent. The government's response was quick but cautious. Two presidential appointees eventually became ardent supporters. Vannevar Bush, who headed the Office of Scientific Research and Development, told Secretary of War Henry Stimson that "nothing should stand in the way of putting this whole affair through to conclusion . . . at the maximum speed possible." Meanwhile, James Conant, chairman of the National Defense Research Committee, recommended four different methods of producing the ingredients necessary for the bomb—just to be certain that at least one of them worked. Bush and Conant's advocacy led President Roosevelt to increase atomic weapons funding from $6,000 in 1940 to $85 million in 1942.

It was led by the United States with the support of the United Kingdom and Canada. From 1942 to 1946, the project was under the direction of General Groves; physicist J. Robert Oppenheimer was the scientific director of the Los Alamos National Laboratory that designed the actual bombs. From 1942 to 1946, the Manhattan Project grew to employ more than 130,000 people. Research and production took place at more than 30 top secret sites across the United States, the United Kingdom, and Canada.

At first, the research was based at only a few universities—Columbia University, the University of Chicago, and the University of California at Berkeley. A breakthrough occurred when Fermi led a group of physicists to produce the first controlled nuclear chain reaction. It took place in a doubles' squash court under the concrete stands of the University of Chicago's Stagg Field. Work began on Chicago Pile-1 on November 16, 1942. Some 45,000 graphite blocks, 80,590 pounds of uranium oxide, and 12,400 pounds of uranium metal were assembled in a somewhat spherical shape 25 feet wide and 20 feet tall. Control mechanisms were put into place, instruments to measure neutron flux and reproduction were installed, and safety systems were prepared. On December 2, 1942, Fermi and his team began removing control rods, and just as the physicist had predicted, he had a chain reaction, one that grew larger with every passing second. After this milestone, funds were allocated more freely, and the project advanced at breakneck speed. Nuclear facilities were built at Oak Ridge, Tennessee, and Hanford, Washington.

Five main siting criteria were developed by a team of DuPont engineers, University of Chicago Metallurgical Laboratory scientists, and staff from the US Army Corps of Engineers: (1) a manufacturing area measuring roughly 12 by 16 miles, (2) at least 10 miles from the nearest public highway or railroad, (3) at least 20 miles from the nearest town of 1,000 or more, (4) an available water supply of at least 25,000 gallons per minute, and (5) an electrical supply of at least 100,000 kilowatts. Based on these criteria, the site selection team chose three potential locations for evaluation.

One

It All Started with Water

In the Pacific Northwest, a massive river flowing for more than 1,200 miles from the Canadian Rockies to Astoria, Oregon, would catch the attention of the War Department. The Columbia River is the fourth-largest river by volume in the United States, discharging an average 160 million acre-feet of water every year, or 265,000 cubic feet per second, at its mouth. Arguably the most important criteria of selecting a site for a secret project, the Columbia offered a near limitless supply of the clean, cold water that would be necessary to operate and cool the "piles," later known as reactors.

The crucial role eastern Washington would play in the war effort began with harnessing the power of the mighty Columbia River. President Roosevelt's New Deal programs aimed to offer recovery and limited relief during the Depression by providing funds for public works projects and thus jobs for the unemployed. The Pacific Northwest was hungry for economic expansion and the construction of Bonneville Dam and, most dramatically, the construction of Grand Coulee Dam (1942) on the Columbia River west of Spokane, Washington, positioned the state as the biggest producer of hydropower in the United States. A mass of concrete standing 550 feet high and 5,223 feet long, or just shy of a mile, Grand Coulee Dam is one of the largest structures ever built by humankind. At one point in construction, crews worked nonstop for 24 hours, placing an average of one cubic yard (202 gallons) of concrete every four seconds and setting a record. In September 1939, a total 400,000 cubic yards of concrete was placed. Nearly 11,000 men worked more than 27 million man-hours to divert the river, excavate the foundation, and place concrete, and of those men, 45 workers died in the process. On October 4, 1941, Coulee's first generator was placed into service. On January 1, 1942, the US Bureau of Reclamation accepted the dam. The dam's second and third generators were in service by April 7, 1942, and completion of the next six units was given high priority.

The Columbia River is the greatest natural resource in the Pacific Northwest. Starting in Canada and flowing to the Pacific Ocean in Astoria, Oregon, the river has been the lifeblood of the original tribes of the plateau—Yakama, Umatilla, Wanapum, Nez Perce, and Colville—and early settlers who tapped its water for irrigation to grow orchards of cherries, apples, grapes, and other tree fruits.

The Columbia was vast and unobstructed until a massive construction project of President Roosevelt's New Deal put over 8,000 unemployed Americans to work beginning in 1933. Considered one of the seven civil engineering wonders of the United States, Grand Coulee Dam is one of the largest structures ever built, with an initial price tag of $540 million.

The construction of the Grand Coulee Dam on the Columbia River was the crown jewel of President Roosevelt's public works projects. However, the hope of irrigation to more than 500,000 acres and massive hydroelectric power production were not enough for the dam to gain the full support of the federal government.

The battle to build Grand Coulee Dam raged, and after years of delays, on July 27, 1933, the president appropriated $63 million for the beginning stages of the dam. Life changed quickly and dramatically once work began on the dam. Not only did the undertaking of this massive project forever change the shape of the river, but it also created towns where nothing but sagebrush, sand, and rocks had previously existed.

The Great Depression and President Roosevelt's subsequent New Deal program gave the required backing to the Grand Coulee Dam, as dam construction promised long-term employment for thousands and continuing economic support to the region. President Roosevelt visited the construction site on October 2, 1937. (Courtesy of University of Washington Digital Collection.)

Grand Coulee Dam was the largest Works Progress Administration (WPA) project in the country and was a centerpiece of President Roosevelt's New Deal. The dam was dedicated on March 22, 1941, after eight years of construction. In 1951, a feeder canal was dedicated by emptying jugs of water from each state in the union, representing the entire country's contribution. (Courtesy of Bureau of Reclamation.)

Two

THE WAR EFFORT IN WASHINGTON STATE

The war effort was not limited to the secret work at Hanford. The aluminum industry became the first major industrial customer of Columbia River hydropower. The first contract was given to the Aluminum Company of America (ALCOA) to supply electricity for a smelter in Vancouver, Washington. The first transmission line from the Bonneville Dam was completed to Vancouver. With that smelter, the Northwest aluminum industry was born. Other aluminum smelters were soon constructed. Reynolds Metals Company constructed the next smelter in Longview, Washington, about 40 miles north of Vancouver, in 1941. Other plants were built by the Defense Plant Corporation, which was formed by the federal government to invest in industrial production. The plants were dispersed geographically around the Northwest so that they could benefit multiple communities and be sold after the war; however, during the war years, the Northwest produced one-third of the nation's aluminum.

The Boeing Company in Seattle, Washington, became a primary consumer of the aluminum from Northwest smelters. Boeing had introduced the Stratoliner just 16 months before the United States entered World War II. Sales of commercial transports came to a halt. Suddenly, the country needed to collectively produce a great quantity of warplanes as quickly as possible. Cooperation, rather than competition, between airplane manufacturers made the best use of the country's resources. On June 20, 1941, the US Army Air Corps became the US Army Air Forces (USAAF). It has been estimated that electricity from Grand Coulee Dam alone provided the power to make the aluminum in about one-third of the planes built during World War II.

ALCOA met the wartime challenge. In three years, ALCOA built over 20 plants, including 8 smelters, 11 fabricating plants, and 4 refineries, and operated them for the government. Total industry investments during World War II rose to $672 million, of which $474 million were ALCOA investments. ALCOA built the first Pacific Northwest aluminum plant (above) in Vancouver, Washington, in 1939, and when completed, it produced 115,000 tons per year.

Reynolds Corporation built a smelter in Longview, Washington, in 1941. In 1942, ALCOA built the Mead smelter in Spokane, Washington, and a smelter in Troutdale, Oregon, and the Olin Corporation constructed one in Tacoma, Washington. In addition to this increased production capacity, tons of aluminum was collected in scrap metal drives that were held across the country during the war.

To serve the USAAF during World War II, Boeing in Seattle produced the country's most important heavy bombers, the B-17 and the B-29, and Boeing workers were building B-17s at a rapidly increasing rate. The rooftops of Boeing Plant 2 were carefully camouflaged to conceal the real purpose of the buildings. (Copyright© Boeing.)

It was after the bombing of Pearl Harbor in December 1941 that Boeing went to great lengths to confuse possible enemy reconnaissance planes. Burlap houses and chicken wire lawns covering Boeing's airplane assembly plant in Seattle ensured that the bomber manufacturing center looked like a quiet suburb on more than 26 acres. (Copyright© Boeing.)

On September 22, 1942, President Roosevelt toured the Boeing Seattle plant, where B-17Fs were under production. There, the president saw both men and women ("Rosies") assembling cockpits, riveting parts to fuselages on B-17G tail sections, and riveting skin onto the tail of a B-17F, along with the last stage of production for the B-17Fs. (Copyright© Boeing.)

The Seattle plant turned out 16 complete B-17s a day, and the G-Model Flying Fortresses were delivered to the combat modification center in Kansas. The 5,000th Boeing B-17 Flying Fortress was signed by every worker. The last B-17 rolled off the production line on April 13, 1945, and the plant then began production of the B-29. (Copyright© Boeing.)

BOEING FLYING FORTRESS
(B-17G)

Engines: Four 1,200 h.p. Wright Cyclones
Wing span: 103 ft. 9 in.
Length: 74 ft. 9 in.
Height: 19 ft. 1 in.
Top speed: over 300 m.p.h.

Gross weight: over 65,000 pounds
Service ceiling: over 40,000 feet
Armament (.50-cal.): 13 guns
Crew: 6 to 10
Wing loading: 38.5 lbs. sq. ft.

In response to the Army's request for a large multiengine bomber, the B-17 prototype went from design board to flight test in less than 12 months. The B-17 was a low-wing monoplane that combined aerodynamic features of the XB-15 giant bomber and the Model 247 transport. Armed with bombs and five 0.30-caliber machine guns, it was the first Boeing military aircraft with a flight deck instead of an open cockpit.

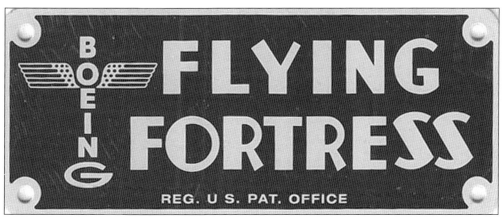

Mounted on the cockpit instrument panel, the Flying Fortress nameplate adorned every one of the bombers that left the factory floor. Reportedly, the term "Flying Fortress" was first used in an article that appeared in the *Seattle Times* on July 16, 1935, and thereafter, it became a symbol of American supremacy in the skies.

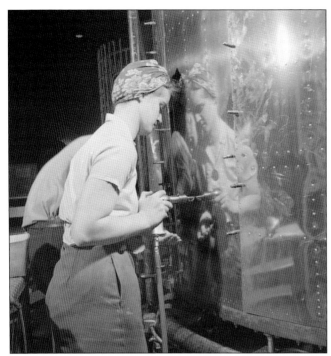

The first B-17s saw combat in 1941 when the British Royal Air Force took delivery of several B-17s for high-altitude missions. The B-17E, the first mass-produced model of the Flying Fortress, carried nine machine guns and a 4,000-pound bomb load. Boeing plants built a total of 6,981 B-17s in various models, and another 5,745 were built under a nationwide collaborative effort of Douglas Aircraft Company and Lockheed Martin subsidiary Vega.

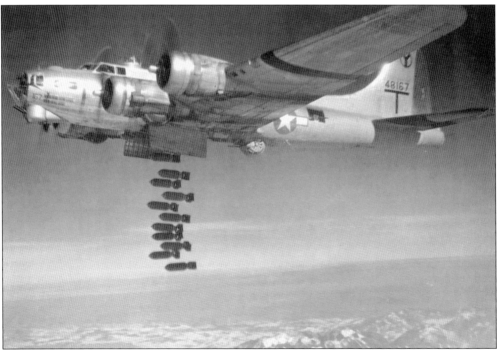

From its prewar inception, the military touted the B-17 as a strategic weapon. It was a potent, high-flying, long-range bomber that was able to defend itself and return home despite extensive battle damage. With a service ceiling greater than any of its Allied contemporaries, the B-17 established itself as an effective weapons system, dropping more bombs than any other US aircraft in World War II.

Three

Importance of
Going Inland

After Pearl Harbor, the Navy approved the relocation of Seattle's Sand Point Naval Air Station in southeastern Washington to Pasco, which was chosen for its good flying climate and abundance of arid, unused land. By July 1942, a huge air strip was being bulldozed into the sagebrush land right next to town. In January 1943, the Pasco Naval Air Station (NAS) began training hundreds of naval pilots and mechanics. It boasted 70 buildings and a large contingent of Women Accepted for Volunteer Emergency Service (WAVES) performing office work and technical work.

Early in 1942, the US Army Corps of Engineers selected another 459-acre site in Pasco for an engineer supply depot, one away from the coast and thus with less risk of attack. Construction started on May 15, 1942. The depot supplied items of general engineering and construction equipment to posts, camps, and stations in Washington and Oregon. Over 95 percent of the equipment held at Pasco was sent to the Soviet Union as part of the Lend Lease program (enacted in March 1941 through August 1945). Officially named the Pasco Holding and Reconsignment Point, it was referred to as Big Pasco. Between 1942 and 1945, over 2.1 million short tons of freight were handled. From the beginning, Big Pasco experienced a severe labor shortage due to two other government projects in the area. Early construction was completed by African American service units. Hiring announcements were made for men up to age 60 with a fourth grade education or six months of manual labor experience. Civil Service called for women who were typists and stenographers, but because of the manpower shortage, women stenciled and painted shipping descriptions on crates and drove forklifts. Italian prisoners of war (POWs) were also requested to relieve the labor shortage. Students worked at Big Pasco during the summer. In May 1943, the War Dog Training and Reception Center in San Carlos, California, provided 12 Great Danes for patrol. By August 15, 1942, a total of 16 buildings had been erected with 1.7 million square feet of storage.

Big Pasco was one of the busiest Army depots during World War II, thanks in part to the Lend Lease policy, officially known as the Act to Promote the Defense of the United States. This program operated from 1941 to 1945 and provided food and materials to US allies, such as France, Great Britain, China, and the Soviet Union. As many as 225 railcars per day were handled during peak operations. Due to its inland location, Pasco was an attractive location for a holding and reconsignment point because of the fear of the Japanese bombing the seaboard. The Pasco facility closed in 1946 but was briefly reopened during the Korean War. Eventually, the Port of Pasco obtained the property. (Courtesy of Franklin County Historical Society.)

To help cope with the shortage of available labor, Italian POWs who had been brought to the United States and put into camps were requested for service. After pledging an oath that they would not engage in combat or conduct sabotage, they became part of a service unit, but not before being screened to weed out any Nazi or Fascist sympathizers. (Courtesy of Franklin County Historical Society.)

The Italian Service Units (ISUs) consisted of Italian POWs who had volunteered to work for the United States, and because the Italian government had given permission for the program, the prisoners were allowed to participate in war-related jobs. Numerous camps were established in eastern Washington to house these detained prisoners, including the Pasco Holding and Reconsignment Point. (Courtesy of Franklin County Historical Society.)

During World War II, more than 51,000 Italians were brought to the United States as enemy prisoners of war. Of those, almost 45,000 agreed to participate in what was known as Italian Service Units, which afforded them the opportunity to earn money and have moderate freedom to interact with Americans despite limited mobility. The Italian prisoners who declined involvement in ISUs were contained in isolated prison camps in Texas, Hawaii, Arizona, and Wyoming. On July 30, 1943, the 255th Quartermaster Salvage and Repair Company arrived in Pasco with 200 men. Their primary tasks were loading and unloading freight and driving equipment. Many were given jobs as forklift operators, singing the entire time as they worked. When the 255th was deactivated in February 1945, they were sent to Seattle for transport back to Italy. (Courtesy of Franklin County Historical Society.)

Pasco's aviation history goes back to 1926 when Varney Air Lines commenced regular airmail service between Pasco, Washington, and Elko, Nevada. The Pasco Airport opened in 1932 as the Franklin County Airport. After the United States entered World War II, the Navy purchased the airport for $1 an acre. Military construction started in March 1942, and the field was commissioned on July 31, 1942. (Courtesy of Franklin County Historical Society.)

Five months later, the field became the first to receive a contingent of Navy WAVES. As the Pasco NAS, it served as a primary training field. During the first part of the war, the field was used to prepare new pilots for combat training. (Courtesy of Franklin County Historical Society.)

During the last half of the war, the Pasco NAS mission shifted to training established pilots returning from battle in the use of newer aircraft and rebuilding carrier-based squadrons of planes that had been shot up in action against the Japanese in the Pacific. At its peak in 1943, the station had 189 instructors, 800 students, and 304 aircraft. (Courtesy of Franklin County Historical Society.)

The Navy had discontinued operations by December 1945, and the base was inactivated on July 1, 1946. After the war, the City of Pasco purchased the base from the government for a consideration of only $1. In 2011, the Port of Pasco commissioners agreed to preserve the original NAS control tower. (Courtesy of Franklin County Historical Society.)

Cartoonist Milton Caniff drew a weekly comic strip, *Male Call*, and made it available at no cost to military newspapers. Caniff visited veterans to appropriate true stories of base camp antics and learn GI slang for his wildly popular army strip. The strip was a gag-a-week series aimed at boosting the morale of servicemen and women and was oriented towards mild humor and pin-up art. (Courtesy of Franklin County Historical Society.)

Caniff's most popular pin-up girl was Miss Lace. In June 1943, Caniff drew a special Miss Lace for the Pasco NAS's newspaper *Sky-Writer*. Caniff was unable to defend his country and saw this as an opportunity to donate his time and wit to those on the war front. With respect to Miss Lace, Caniff said that "her function was to remind service men what they were fighting for." (Courtesy of Franklin County Historical Society.)

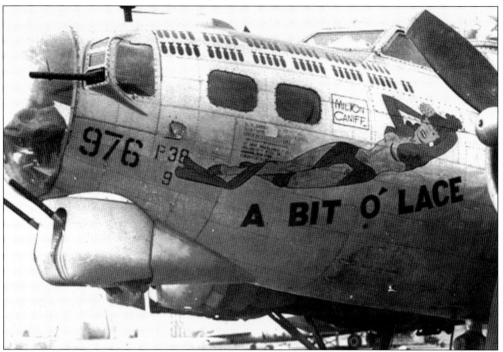

The saucy Miss Lace was popular nose art for aircraft during World War II. "A Bit o' Lace" appears here on the nose of a B-17G. Based on a sketch provided by Milton Caniff, the portraiture was painted by Nick Fingelly of the USAAF 709th Squadron, 44th Bombardment Group. (Courtesy of USAAF Nose Art Research Project.)

The strip *Male Call* began on January 24, 1943, although the general public never had the chance to see it when first published. Yet Miss Lace had a cult following as soon as *Male Call* debuted in military camp newspapers. Caniff continued *Male Call* until seven months after V-J Day, bringing it to a conclusion on March 3, 1946. (Courtesy of Bruce Bates.)

Four

SPECIAL AIRBASES PROTECTING HANFORD

In addition to Pasco NAS, several other airbases were built in the region around Hanford to provide support and protection. The following passage was provided by Mike Miller of Airfield Estates:

> Just prior to the United States entry into World War II, the Olympic Air Transport Company contacted our founder, H. Lloyd Miller, about the possibility of leasing land from him for a period of a few years in order to build an airbase to train military pilots. Lloyd, a successful realtor and landowner, knew it would be several years before the arrival of Roza irrigation water so he agreed to lease out his property. Construction of the airbase commenced in the latter part of 1941. The buildings erected on the site included a 70-foot water tower, several airplane hangars, a mess hall, barracks, and several smaller storage buildings. Three dirt runways were also formed, each of which was over a half mile long. The pilots trained primarily on bi-winged Stearman Airplanes. The airbase continued operations until the mid 1940's. The unofficial story is that the military airbase had ulterior motives. It was not just designed for training pilots. During the war years, there were six small airbases that made a horseshoe pattern around Hanford. These bases were located near Moxee, Ephrata, Connell, Othello, Richland, and 'Airfield's' base in Sunnyside. These bases were strategically located around Hanford in order to conduct surveillance over the highly classified Hanford Engineer Works. The airbase also provided potential defense if we came under attack because the runways were long enough to allow for the landing of larger fighter and attack aircrafts.

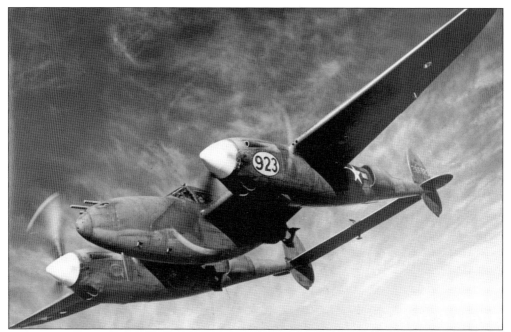

A large base in Moses Lake, Washington, named Moses Lake Army Air Base (AAB), was activated on November 24, 1942, and the first operational training unit (OTU) was the 482nd Fighter Squadron, which conducted twin-engine fighter training for P-38 Lightning fighters (pictured). On April 5, 1943, the 396th Bombardment Group became a second OTU at the base, providing first phase heavy bomber training for the B-17 Flying Fortress.

The airfields were not only designed for training, they were strategically located to provide surveillance. The town of Moses Lake, originally incorporated as Neppel, Washington, in 1911, was an ideal location for the Army Air Base. It was isolated from prying eyes and near the top secret Hanford Engineer Works (HEW). (Courtesy of Moses Lake Museum & Art Center.)

The War Department spent several million dollars during World War II to build an Army Corps Training Airfield adjacent to the Walla Walla municipal airfield. The 91st Bomb Group was the first unit to be trained in B-17 Flying Fortress airplanes at the Walla Walla Army Air Base. In 1944, a training base for B-24 Liberator crews was established there. (Courtesy of the 91st Bomb Group.)

During World War II, there was an African American Women's Army Corps (WAC) squadron stationed at Walla Walla Army Air Base. This squadron, as well as African American servicemen, faced segregation in the barracks, mess halls, and recreation centers. There was also a German POW camp at the Walla Walla Fairgrounds Stockade.

The Umatilla Chemical Depot (UMCD), pictured, was a 19,728-acre military facility located in northeastern Oregon. It was established as an army ordnance depot in 1941. The depot's role during World War II was to store and maintain a variety of military items, such as blankets and ammunition. The UMCD facility is slated for realignment under the Department of Defense's Base Realignment and Closure (BRAC) program.

The UMCD, formerly known as the Umatilla Depot Activity (UMDA), was also an ordnance facility for storing conventional munitions during World War II. Beginning in 1941, a total of 1,001 ammunition storage igloos were built. The depot has assumed a number of other roles over the years, such as ammunition demolition, renovation, and maintenance. In 1962, the Army began storing chemical weapons there. The last of those weapons was destroyed in 2011.

Five

RELOCATION OF JAPANESE FARMERS

The first recorded settlers of Japanese origin to the Yakima Valley were the Kimitaro Ishikawa family, who arrived in 1891. Most plots farmed by Japanese immigrants comprised fewer than 40 acres, although some Japanese-owned farms produced larger-scale crops of alfalfa, onions, and potatoes. Immediately following the Japanese attack on Pearl Harbor on December 7, 1941, six leaders in the Yakima Valley Japanese community were arrested and held in the Yakima County jail, for no other reason than they were Japanese. Japanese Americans offered their services to help with home front tasks related to the war effort. Nisei schoolchildren were permitted to continue attending their classes, and many non-Japanese Yakima Valley residents rallied around their Japanese American neighbors.

On January 14, 1942, President Roosevelt issued Presidential Proclamation No. 2537, requiring enemy aliens (which included the Issei) to register. On January 23, 1942, the Wapato Japanese Language School burned down under suspicious circumstances. Lt. Gen. John DeWitt, head of the Western Defense Command, issued Public Proclamation No. 1, delineating the western half of Washington, Oregon, and California and the southern third of Arizona as military areas from which Issei and Nisei must be removed. On May 26, 1942, Lieutenant General DeWitt announced that Issei and Nisei in six central Washington counties, including Yakima County, would be evacuated by June 7. On May 25, 1942, a 50-member army field artillery unit arrived in Wapato to process evacuees. A number of Nisei assisted in this task, processing themselves and their families for imminent evacuation. On the evenings of June 4 and 5, 1942, these Japanese Americans, their belongings limited to what they could carry, boarded trains for the Portland Livestock Exhibition Grounds, then on to the Heart Mountain Relocation Center, 12 miles northwest of Cody, Wyoming, in early August. About 800 miles from home, the Japanese and Japanese Americans were detained for the remainder of World War II.

The Japanese came to the Yakima Valley to work the land for others but quickly started their own farms. Over 1,200 Japanese, many of them American citizens who had proof of citizenship, land leases, and college degrees from the State College of Washington (now Washington State University) lived in and around Wapato, where they built a Buddhist church and community gym. (Courtesy of Yakima Valley Museum.)

Racism was an ongoing problem and came to a head two months after the bombing of Pearl Harbor when President Roosevelt signed Executive Order 9066, forcing Japanese relocation to an internment camp in Wyoming. They left behind farms, homes, cars—all of their property—and took a few suitcases, whatever they could carry.

Six

FRANKLIN T. MATTHIAS, THE FATHER OF HANFORD

It could be argued that the 34-year-old civil engineer and reserve officer from Gidden, Wisconsin, was the "Father of Hanford." One of Gen. Leslie R. Groves's top assistants, it was Franklin T. Matthias who was charged with locating a suitable site for the Manhattan Project's plutonium production facilities. And it was Matthias who, after scouting possible locations throughout the Northwest, reported back to Groves that Hanford was "the only place in the country that could match the requirements." Robley Johnson, who was the official photographer at Hanford, is quoted in an interview with Ted Van Arsdol in 1991:

> Anyway, I had come in and I was working for Colonel Matthias. They brought in a picture of General Groves to me one day, and they said, 'make 50 copies of this'. I turned it over and on the back of it said, 'Major General Groves, Head of this Government's Atomic Bomb Plant.' And I'll never forget it. I walked out, and I couldn't believe it.
>
> Colonel Matthias, he was great. He was a nice fellow. He was a good man for the job, an excellent man. I consider Matthias a good friend. I think we got in the Jeep one day and chased a bunch of wild geese up the river to try and get some pictures of them. I think he was trying to unwind and just get away from people. I don't think he was particularly interested in the geese.
>
> And I had cases where scientists would come in under aliases. I remember one day I came over and Colonel Matthias and somebody else said, 'Rob we'd like for you to forget where you were today.' I said, 'Yes sir, yes sir.' "

As the area engineer, Col. Franklin T. Matthias (1908–1993) directed construction of Hanford Engineer Works. General Groves appointed the 34-year-old lieutenant colonel of the US Army Corps of Engineers to the Hanford project in 1942. (Courtesy of CJP.)

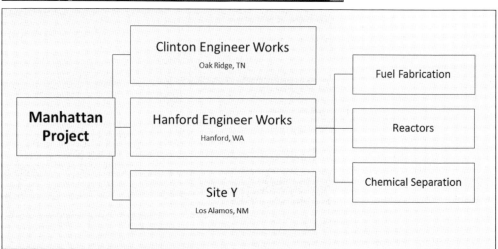

Colonel Matthias had considerable experience in civilian construction and recruited both military and civilian personnel, many from other US Army Corps of Engineers projects, to form the operating nucleus of a burgeoning office organization. Initially, the intention had been to locate the plutonium plant at the Clinton Engineer Works in Oak Ridge, Tennessee, but concerns had arisen about the dangers of an atomic explosion, and Knoxville was only 20 miles away.

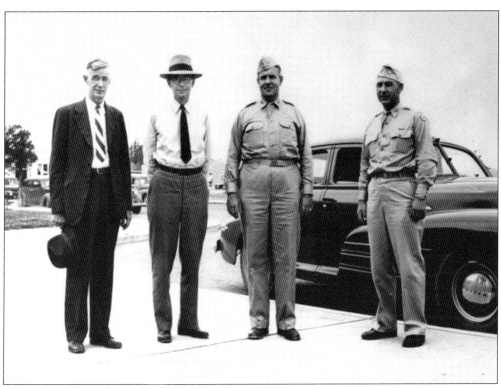

General Groves instructed Colonel Matthias to take a survey team to find a suitable site for the plutonium production plant. Above, the team is, from left to right, Vannevar Bush, James B. Conant, General Groves, and Colonel Matthias. They choose the area around Richland, Washington. The flat desert land, the proximity of the Columbia River, and the power from Grand Coulee Dam solidified the site selection. (Courtesy of CJP.)

To complement DuPont's field construction organization at Hanford, Colonel Matthias established major divisions to monitor the many construction-related activities of DuPont. He revamped the Hanford area office by expanding the production division, forming a new engineering and maintenance operations division, and, to the extent necessary, reorganizing the security, safety, labor relations, fiscal audits, and community affairs sections. (Courtesy of CJP.)

DuPont officials frequently visited the Hanford Site during construction. Colonel Matthias later recalled, "As far as my relationship with DuPont was concerned, we had differences from day one. I remember one time Granville Read called up Groves and said Matthias and Church were having a big argument about something and what should we do? Groves then replied, 'Well, if those two guys don't have some arguments, then neither of them are worth a damn.' " (Courtesy of CJP.)

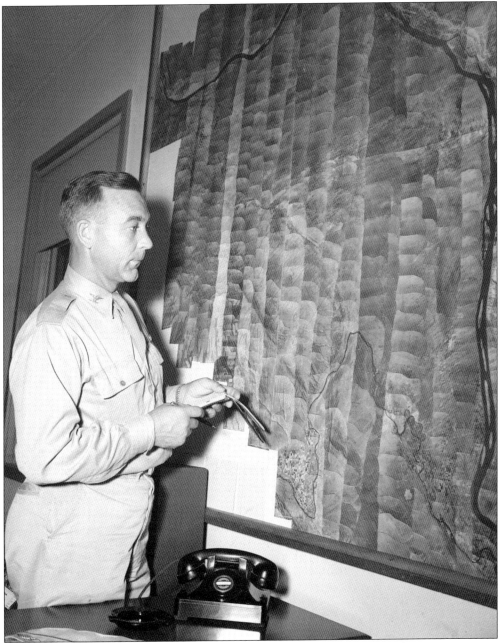

Colonel Matthias exercised more autonomy than the Manhattan Project's other area engineers. Construction work commenced on the 400,000-acre site in April 1943. Matthias supervised the construction of 554 buildings, 386 miles of roads, 158 miles of railroad track, 3 chemical separation plants, and the world's first three production-scale nuclear reactors. (Courtesy of CJP.)

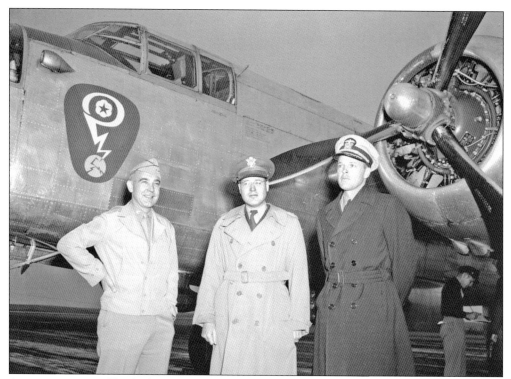

As area engineer at Hanford Engineer Works, Colonel Matthias was responsible for the day-to-day oversight of one of the largest construction projects ever seen in the United States. It was his job to ensure coordination among the other Manhattan Project locations, and he spent countless hours in top secret meetings with representatives from around the country. Here, Matthias (left) is shown greeting Col. Kenneth Nichols (center) and Comdr. Frederick Ashworth (right) at the Pasco Naval Air Base. (Courtesy of CJP.)

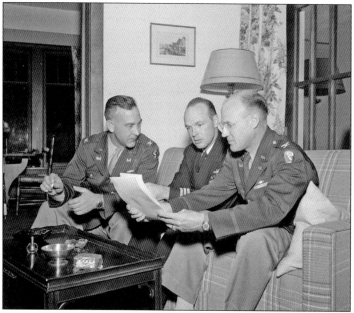

From left to right, Matthias, Ashworth, and Nichols meet in the Matthias home to discuss progress at Hanford Engineer Works. Ashworth was a US Navy officer who ultimately would be the weaponeer on the B-29 that dropped the plutonium bomb on Nagasaki, Japan, and Nichols was a district engineer of the Manhattan Engineer District. (Courtesy of CJP.)

Seven

EXERCISING
EMINENT DOMAIN

When the Army arrived in the Hanford area in 1943, it was not just white farmers and ranchers who had to leave the land their families had settled 80 years earlier. The area had served as home to generations of Native American tribes, including the Wanapum, Yakama, Umatilla, Nez Perce, and Colville, collectively referred to as the Tribes. They had settled or seasonally camped in the area because of the water and abundant plant and animal life. This abundance was due to what later became known as the Ice Age Floods, which had deposited rich and fertile soils where the Tribes had everything they needed because they lived according to the seasons.

When the government arrived in 1943, the Wanapum tribe was still resident in the area, fishing, hunting, and gathering where their ancestors had lived. They were forced to abandon their camps along the Columbia River and relocate to Priest Rapids. Though the tribe sought to return to their traditional fishing camps for a brief period in the fall, access was ultimately denied for security reasons.

The town of Hanford was served by the Chicago, Milwaukee & St. Paul Railway Company, enabling local farmers to ship produce across the continent. About 300 people called Hanford home when, on February 8, 1943, Secretary of War Henry Stimson began land acquisition proceedings under the Second War Powers Act. Some residents saw the March 6 newspaper posting; others received a notification in the mail. Still others were made aware only when an army jeep pulled up in front of their homes. As much as 90 days to as little as 48 hours were given to comply with the directive. The town was condemned.

One of the state's oldest towns, White Bluffs—named for the distinctly chalky cliffs nearby —was first located on the east bank of the Columbia River, just seven miles upstream from Hanford. White Bluffs was established in part to serve both as a ferry and as a landing for Portland riverboats supplying gold miners on their way to British Columbia. The only building that still stands is the First Bank of White Bluffs, a structure stout enough to withstand a 1922 robbery attempt in which burglars tried to blow the safe with nitroglycerin.

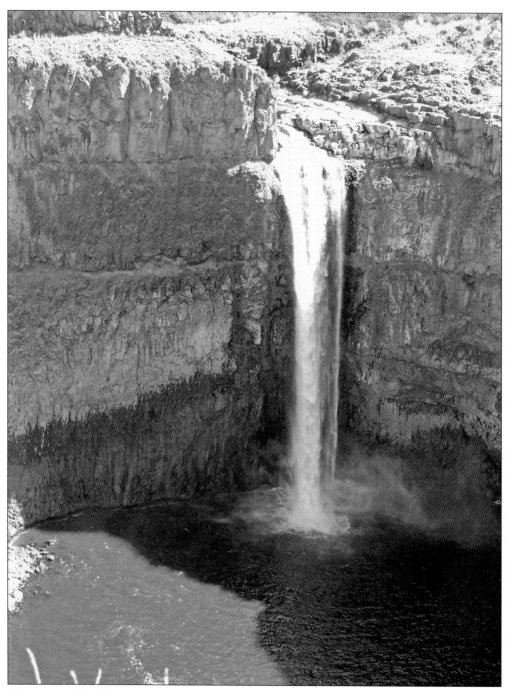

The Ice Age Floods began as early as one million years ago, with the most recent occurring around 13,000–15,000 years ago. The floods inundated the Hanford plateau dozens, if not hundreds, of times. As the water moved across eastern Washington at speeds estimated at 45–55 miles per hour, it eroded the basalt, creating a spectacular array of channeled scablands, coulees, and waterfalls, such as Palouse Falls located near the Hanford Site.

Where the Ice Age floodwaters ponded behind obstacles like Wallula Gap, they left behind regular layers of sediment called rhythmites, such as those shown here along the Columbia River. The town of White Bluffs took its name from rhythmites deposited by the Missoula Flood, which formed due to an eddy behind the Saddle Mountains. (Courtesy of Bruce Bjornstad.)

For over 10,000 years, Native American tribes had lived in the Columbia Basin. Until the early 1900s, the culture of the Tribes was based on a yearly cycle of travel from hunting camps to fishing spots to celebration and trading camps. The seasonal round shown here depicts the yearly cycle. (Courtesy of Lynn Kitagawa.)

Several distinct Tribes utilized the lands that would become the Hanford Site. All but the Wanapum had ceded their lands in the Treaty of 1855, yet retained right of access to traditional fishing and hunting grounds in the region. The Tribes traveled seasonally to collect their food and prepared it to be eaten or saved for the winter. (Courtesy of Columbia River Inter-Tribal Fish Commission.)

The Tribes followed the same route each year in a large circle from the lowlands along the Columbia River to the highlands in the Blue Mountains. During spring and fall, families camped along the Columbia River at traditional fishing sites to catch and dry enough salmon to use for the year ahead. (Courtesy of Spokane Public Library, Northwest Room, Teakle Collection.)

The Tribes would gather black moss, which was baked to make a cheese-like food. Camas bulbs were dried or baked. In the fall, the Tribes would return to the lower valleys and along the Columbia River again to catch the fall salmon run. (Courtesy of Columbia River Project, North West Council.)

Courtesy Washington State Library/Washington State Digital Archives

Berries, roots, onions, nuts, herbs, spices, mushrooms, meat, and fish would be dried into cakes and cached for later use. The cakes were packed into baskets for winter subsistence or commerce. As seasons permitted, some tribal people would head into the mountains to hunt and gather plants and medicines. First Food feasts celebrated these life cycles. (Courtesy of Washington State Digital Archives.)

Fishing was the primary means of livelihood and survival. Conditions along the Columbia and Snake River systems were so good that, depending on where and what season they were fishing, all that was required for a fisherman was a dip net, gaff hook, small spear, or hook and line. (Courtesy of Columbia River Project, North West Council.)

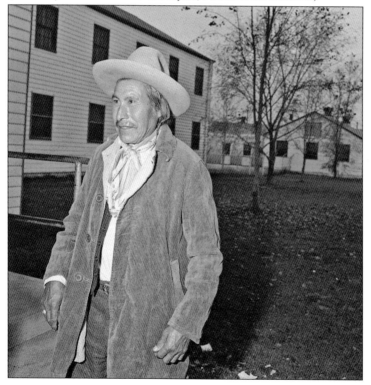

Known as "Johnny Buck," Puck Hyah Toot (1878–1956) was an elder of the Wanapum during the time that they were displaced from their traditional fishing areas and burial grounds at Hanford for the Manhattan Project in 1943. Buck worked closely with Colonel Matthias to ensure access to the Wanapum sites and for their continued care. (Courtesy of CJP.)

As a Wanapum elder, Johnny Buck would wage a long battle to ensure the rights of his people to a home and a place to fish. Once construction at the Hanford Site began, the Wanapum were restricted from using their fishing grounds in the White Bluffs vicinity, downstream from Priest Rapids. (Courtesy of University of Washington Libraries, Special Collections, NA706.)

According to the narrative from an Atomic Heritage Foundation interview, Johnny Buck recollects, "We used to live in the tules [reed huts] until spring, then we take them apart, put them away and we move. First we move after the root feasts, clear up to Soap Lake and Waterville. Then down to Ellensburg. Horn Rapids for fishing. Naches Pass for berries and more fishing for several weeks." (Courtesy of US Fish and Wildlife Service.)

The Atomic Heritage Foundation interview with Johnny Buck continues as follows: "After this we come back to Priest Rapids, where our home was for winter. We just went over this year after year. We just circle the same way every time. When the Army came into Hanford, they said we can't go in there. Some years when this is all over, you can come back and fish again whenever you want to. But, now we can't do that." With the arrival of the government in 1943, access to traditional fishing locations near White Bluffs became restricted. During the early construction of the piles (reactors) at Hanford, Colonel Matthias arranged for the Wanapum to be escorted to their traditional fishing area at White Bluffs, but because of security reasons, these forays had to be curtailed once the reactors came online and began plutonium production in 1944. (Courtesy of US Department of Energy Declassified Document Retrieval System.)

The White Bluffs townsite, named for the spectacular cliffs near the location of the original town, was one of the first Euro-American settlements along the Columbia River in the Washington Territory. In the late 1850s, steamboats began to run from Portland, Oregon, to White Bluffs, and the town became a central point from which river shipments were transferred to pack trains carrying supplies to gold miners in British Columbia. (Courtesy of US Department of Energy Declassified Document Retrieval System.)

In the late 19th century and early 20th century, a number of ferries provided service across the Columbia River; notably at Priest Rapids, Vernita, White Bluffs, Hanford, and Richland. The ferry *Smidget*, shown here, provided transport for automobiles as well as foot traffic across the Columbia River at White Bluffs in the 1930s. (Courtesy of US Department of Energy Declassified Document Retrieval System.)

White Bluffs was established in 1861 on the east side of the Columbia River, across from what are now the 100-F and 100-H areas on the Hanford Site. Floods and the arrival of homesteaders in the late 1890s necessitated a move to the west side of the river. In 1913, when the railroad refused to come directly to White Bluffs, the town moved yet again about a mile and a half to the west. (Courtesy of US Department of Energy Declassified Document Retrieval System.)

When the government arrived in 1943, the White Bluffs region had a population of about 1,000, along with tree-lined streets and white clapboard homes. Businesses included an inn, ice cream parlor, and a bank. When residents were evicted, almost all the buildings were demolished; the only remaining structure is the White Bluffs bank, shown here. (Courtesy of the East Benton County Historical Society.)

The town of Hanford, after which the HEW was named, was settled in 1907 on land purchased by the Hanford Irrigation and Power Company. By 1925, the town was booming thanks to high agricultural demand, and it boasted a hotel, bank, and two schools. The Planters Hotel was built about 1910 on the banks of the Columbia River. (Courtesy of Washington State Historical Society.)

Steamer traffic on the Columbia River was a brisk business before being outpriced by the railroad. Wilbur Russell Todd operated a number of steamers carrying freight and passengers, with stops at Pasco, Kennewick, Hanford, and White Bluffs. This 1915 photograph shows the eponymous *W.R. Todd* having just left Hanford. (Courtesy of US Department of Energy Declassified Document Retrieval System.)

Construction of the Hanford High School began in 1916, and it was dedicated in 1917. For the time, it was a forward-looking design that incorporated Art Deco elements. It was known to have the nicest hardwood flooring around. The school burned in 1936, but it was rebuilt and reopened in 1938. Due to the arrival of the government, the last class graduated in 1942. (Courtesy of East Benton County Historical Society.)

During World War II, the Hanford Construction Camp grew out of the desert in the lands adjacent to the Hanford townsite. The old Hanford High School, shown here in 1954, was used as the construction management office. In later years, it was a popular locale for Special Weapons and Tactics (SWAT) team practice. (Courtesy of US Department of Energy Declassified Document Retrieval System.)

Eight

Documenting the Manhattan Project

One of the first DuPont people on the scene, Robley Johnson arrived on May 2, 1943. At Hanford, Johnson supervised DuPont's photography crew. The War Department's photographs of Hanford were his, although he did not receive formal credit by name. The following excerpts are from "Robley Johnson Remembers," a published interview conducted by Ted Van Arsdol:

I pointed the camera at things half the world never dreamed of.

I remember when I first came, we had a picnic at White Bluffs, near the ferry landing. Colonel Matthias and Major Newcomb and some of those fellows, they had some dealings more with the Indians than I did. Major Newcomb was part Indian himself. He had to go up there, and he said, 'Those damned Indians sat us down, and we had to eat that damned raw fish.' They were dickering, and they had some confabs with Johnny Buck and what have you. He was an old Indian, and I did make a picture of him one day.

People, including me, came out here thinking Washington was the Evergreen State, and got dumped in a desert. I remember my boss came in one day and he said, 'Well, Rob, we got two people on the rolls today. We hired 650 and 648 quit.' The reasons for quitting were isolation, dust and no place to live. For a while, we couldn't hire enough carpenters to build bar-racks. We got over that hurdle and made progress, and eventually I made 145,000 ID photos. We used to have a saying, if you quit Hanford and joined the Army, you were a coward.

And as we got further along and built barracks out at Hanford, why, all the needs were taken care of in the respect of housing and eating and this type of thing. And then we had gas rationing that came in, and they couldn't get out of Hanford. They had to stay. They were a captive audience, you might say-a captive out there. And so, it was just a hurly-burly atmosphere that's all.

DuPont, the engineering company selected for construction at Hanford, sent recruiters to all 48 states at the time, as well as to Alaska and Canada. Many of the Hanford recruits, who were promised the clean mountain air of the Evergreen State, arrived via train in Pasco only to wonder whether they had gotten off at the wrong stop. There were mountains, all right—but as barren as the desert floor upon which the hopeful workers stood. And for many, it did not get any better the longer they stayed, with the heat, the desolation, and the wind—*always* the wind. Speeds in excess of 30 miles per hour are normal in the area; gusts up to 70 are not unheard of. And as if that was not bad enough, there was the sand, which worked its way into the very fabric of the clothes on one's back. Locals started calling them "termination winds." As the stories go, every morning after a sandstorm, people would quit by the thousands, and there would be a long line of workers at the employment office drawing their last check—their "termination pay." (Courtesy of US Department of Energy Declassified Document Retrieval System.)

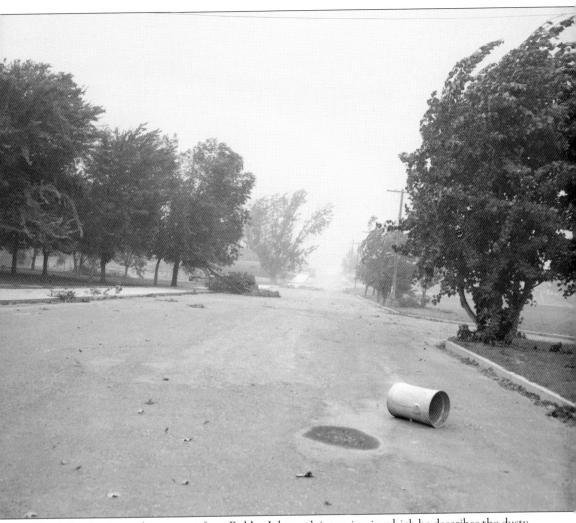

The following is another excerpt from Robley Johnson's interview in which he describes the dusty conditions: "It did get plenty hot, and you'd get the damned dust storms, and you'd come home sometimes and you'd have an inch of dust all around the window sill and you'd have to take out the vacuum and everything. It was kind of hard on the ladies here in Richland when we'd have one of those dust storms. We didn't have any trees then. I have some pictures in my files of all the shingles on the house on one side standing at attention. They were just not laying down, they were all standing up. We had some Jim Dandys, I'll tell you. We used to have a saying that Prosser and Grandview were going by! New recruits, still in Pasco, we'd put 'em on a bus and send 'em out to Hanford. Some of these people would get out there, and we'd have one of these dust storms and they'd get on the next bus and go back home, and 'to hell with it'—we never saw them again." (Courtesy of CJP.)

As many as 50,000 construction workers lived in the Hanford Construction Camp. Eight mess halls served fresh-baked bread, pies, and pastries, along with balanced meals. Food was served family style, and there was no lingering, as there were thousands of dinners to serve. On Saturday nights, the workers would drink beer from the Patriot Brewery, constructed specifically for the Hanford workers. Liquor was rationed. (Courtesy of US Department of Energy Declassified Document Retrieval System.)

Surrounded by barbed wire and separated by gender, the Hanford Construction Camp was likened to a prison. People suffered from depression and homesickness, and there were a number of nervous breakdowns. Construction proceeded at breakneck speed. Above is a view of the Hanford Construction Camp looking east toward the Columbia River at the women's dormitory area. (Courtesy of US Department of Energy Declassified Document Retrieval System.)

Prior to the construction of dormitories, workers were housed in rows and rows of tents and Quonset huts, each of which housed 20 people. By mid-1945, 190-person barracks were housing many of the 50,000 construction workers. Living conditions were crowded and often difficult; thus many men arrived without their families. Housing options were limited for married men who wanted to bring their families. If they were lucky, they would be assigned to a house trailer, but there were far more men who wanted to live in trailers than were available. Many people likened living in the Hanford Construction Camp to being held in prison. But workers made the best of it, establishing friendships that would last a lifetime. (Both, courtesy of US Department of Energy Declassified Document Retrieval System.)

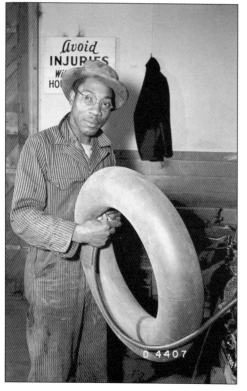

The Hanford Construction Camp was segregated by both race and sex. A July 1944 count of HEW employees indicated that 65 percent were white men, 25 percent were white women, 9 percent were "colored" men, and 1 percent were "colored" women. Once the laboratory division opened in 1945, women were actively recruited, provided they were between 21 and 40, had a high school education, and possessed "pleasing personalities." (Courtesy of US Department of Energy Declassified Document Retrieval System.)

Barracks, mess halls, and even taverns were built to accommodate men, women, or minorities. The trailer camp was likewise segregated, though only by race. It was the only place within the Hanford Construction Camp where married couples could live together. Although African Americans made far more at Hanford than elsewhere around the country, they were generally given unskilled jobs or anything deemed too menial for whites. (Courtesy of US Department of Energy Declassified Document Retrieval System.)

In another passage from his interview, Robley Johnson discusses the security of the site: "We didn't know a thing about the job out here. That was kinda strange, you know, you hear rumbles. But this one—there were just some sort of rumbles, and you'd go out into the field and it was interesting that the crafts knew about these jobs before the front office did, almost. And the word got around that we were dinking around with energy—atomic energy—but the bomb aspect never entered anybody's mind. And there was so much ballyhoo. Every time you turned around there was a loudspeaker going. There was so much security that after a while you kinda got to where you didn't want to know. The pressure was so great, and the tempo was so great of getting this thing built. Well, in fact, there were certain words that if you used, Security came around and had a little chat with you, and atoms was one of 'em. So these were kind of off-limit words. Buzz words you might say." (Courtesy of US Department of Energy Declassified Document Retrieval System.)

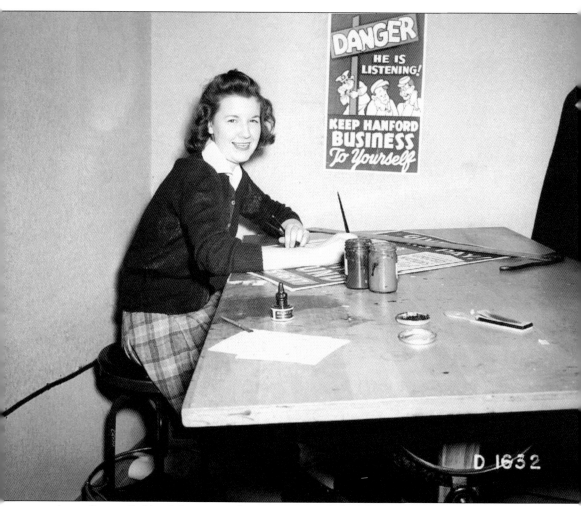

According to Robley Johnson, workers were reminded of the importance of secrecy at every opportunity: "I remember one day flying from Hanford over to Moses Lake. We flew across the desert for some reason, and we landed on this little strip out there. And there were a lot of people at the base at Moses Lake, and one soldier came up to me and said, 'Where did you folks come from?' And we said, 'Over at Hanford.' He said, 'Are you guys buildin' something over there?' I said, 'Oh yeah, something.' And he said, 'How many people do you have workin' there?' I said, 'Oh, I don't know,' and he said, 'Two or three thousand?' I said, 'Something like that,' and we must have had 40,000 at the time. So very little was known. It was a well kept secret, well kept. A lot of speculation and everything, but it was quite a job." (Courtesy of US Department of Energy Declassified Document Retrieval System.)

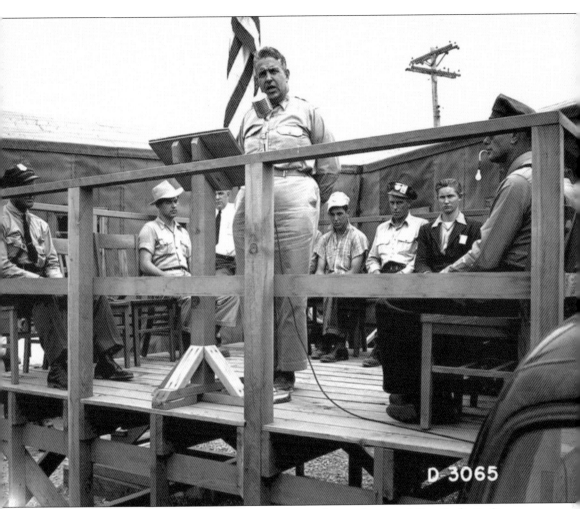

D 3065

"Compartmentalization of knowledge, to me, was the very heart of security," Gen. Leslie R. Groves wrote in *Now It Can Be Told*, his 1983 account of the Manhattan Project. "My rule was simple and not capable of misunderstanding—each man should know everything he needed to know to do his job and nothing else." His "simple" rule was strictly enforced at the Hanford Construction Camp and throughout the site by HEW security forces and undercover FBI agents, who ensured that work-related topics were absent from any conversations between coworkers and family members. Years later, former workers still speculate about fellow employees who talked one day and were mysteriously gone the next. While no espionage is known to have occurred at Hanford during the war, author Richard Rhodes reported that the design of the Soviets' first nuclear reactor closely resembled Hanford's test reactor—a coincidence that, at the very least, suggests some success on the part of Russian spies. (Courtesy of US Department of Energy Declassified Document Retrieval System.)

Finding skilled labor and even unskilled laborers for the construction of Hanford Engineer Works in the numbers needed during wartime was a challenge throughout the project. Advertisements for construction workers were circulated nationwide, like this one from the *Milwaukee Sentinel* on Tuesday, June 6, 1944. The remote location of the site made recruiting even more difficult. Between 1943 and 1945, it took 262,040 interviews by DuPont recruiters to find 94,307 people to hire. (Republished with permission of Journal Sentinel, Inc. From the *Milwaukee Sentinel*, June 6, 1944, edition; permission conveyed through Copyright Clearance Center, Inc.)

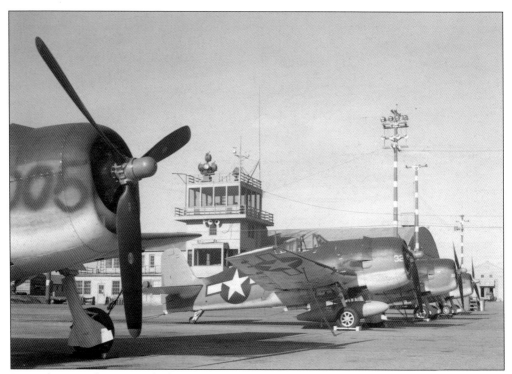

More than anything, Hanford Engineer Works required skilled labor—welders, electricians, plumbers, steel workers, masons, carpenters, and pipe fitters. But then, so did everyone else, including the neighboring Pasco Naval Air Station (pictured) and the Pasco Engineering Depot, both actively supporting the war effort. The Kaiser Shipbuilding Company was another one of Hanford's direct competitors in terms of labor. (Courtesy of Franklin County Historical Society.)

More than one former Hanford Construction Camp resident likened the experience to army life or prison. Barracks, barbed wire fence, mess halls, loneliness—the comparisons might be unduly harsh, but they are not completely inaccurate. Yet steps were taken to make residents feel at least some sense of normalcy. Each trade—carpenters, electricians, et al.—fielded a baseball team in an organized league. (Courtesy of US Department of Energy Declassified Document Retrieval System.)

Marquee big bands like Kay Kyser and Henry King performed sold-out shows in an auditorium that could accommodate 3,000 dancing couples. The Esquire Girls performed at the 1944 Christmas show. Hanford Construction Camp residents and their families made do with what they had, even if it was just a lonely desert outpost miles from anywhere. (Courtesy of US Department of Energy Declassified Document Retrieval System.)

D·1478

When the government arrived in eastern Washington in the spring of 1943, they forced the eviction of farmers who had to leave fruit on their trees and crops in the ground. World War II had created a national food shortage, so instead of letting fruit and crops go to waste, the government contracted with the Federal Prison Industries to bring in minimum-risk prisoners from McNeil Island Federal Penitentiary to live in Camp Columbia (pictured). The camp was located along the Yakima River just north of Horn Rapids and adjacent to the Hanford Site. These prisoners provided the necessary labor to harvest and process more than 5,600 tons of produce for military use from February 1944 to October 1947. Prisoners were housed in Quonset huts, prefabricated facilities, and barracks. Buildings from the Civilian Conservation Corps facility in Winifred, Montana, were also used in the camp. The facility was also used to house workers building the Hanford project rail lines and later those involved in the US Army Corps of Engineers projects associated with the construction of McNary Dam. In 1966, the land was turned over to Benton County and is presently a day use area called Horn Rapids County Park. (Courtesy of US Department of Energy Declassified Document Retrieval System.)

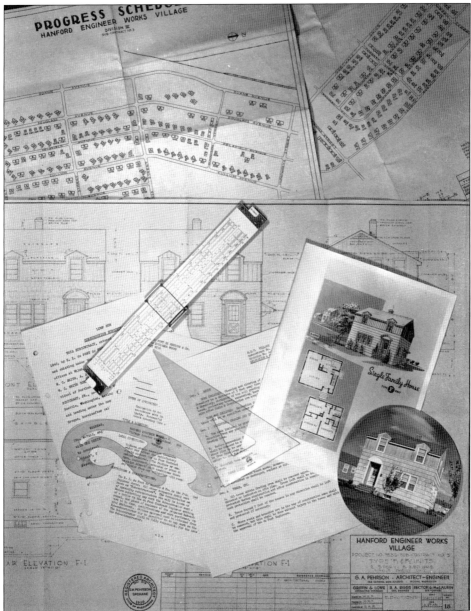

In 1943, Richland became the site for a federally sponsored planned community called Hanford Engineer Works Village, or Richland Village, as it became known, to house DuPont employees. Richland was no more than a crossroads, but it was close to the construction site of the production facilities at the farthest end of the Hanford Site, yet with sufficient distance to ensure both safety and security. The original town of Richland was condemned, and plans were made for a large influx of workers. College-educated physicists, chemists, and engineers, some of them still in their early 20s, arrived at Hanford to work at the frontiers of science. After the residents of Richland Village were evicted in 1943, Hanford's white-collar employees expected to live in the new Richland Village. The federal government designed and constructed an entire new town as quickly as possible specifically for that purpose. The population of Richland Village would go from 247 in 1943 to more than 11,000 in 1944. (Courtesy of C.K. Anderson, helveticka.)

Colonel Matthias made a call to Gustav Pehrson (pictured) at 4:00 a.m. on March 9, 1943. Matthias said a "committee" had recommended the prominent Spokane architect for a large-scale construction project in the desert 160 miles away. Pehrson's response? "Impossible." When Pehrson's phone rang again a few days later, Matthias's tone had changed. "You *will* meet Lieutenant Colonel Kadlec at 2:00 p.m. tomorrow in Pasco." (Courtesy of C.K. Anderson, helveticka.)

The next day, Lt. Col. Harry R. Kadlec's instructions were simple: Pehrson was to design a complete city to house and accommodate 5,700 people (later, 16,000), including houses, utilities, shops, services—everything. Plans and specifications for the first duplex-style house were due in a week and those for the entire city in 75 days. Construction began immediately. (Courtesy of CJP.)

Robley Johnson describes the process by which houses were built on-site as follows: "You bet they built [houses]. Sometimes you'd go to work in the morning and there'd be a hole, just a bare street and you'd come home in the evening and there'd be eight or nine houses built along there. They just had these big scooping machines, and they'd go along and scoop out a basement and they'd scoop out another one, and another one and another one and then another crew would come along and form it up and put it up so at the end of the day the rafters and studdings and all that were preassembled at the location of the old Sacajawea School; it was a sheet-metal shop and a fabrication shop there where they would do that, and all the houses were built in the same pattern." (Both, courtesy of US Department of Energy Declassified Document Retrieval System.)

N
W · E
S

Quilme River

Proposed H.W. R.R.

Proposed

Cypress St.
Yelm St.
Cottonwood
Lincoln
Olympic St.
Pullen St.
Richardson St.
Elm St.

Humphreys St.
Pearl St.
Birch St.
Cedar St.
Chestnut St.
Duportail St.

Coy St.
Beechwood St.
Jefferson St.
H.W.

R.R.

Existing

Wright Ave.
Winslow Ave.
Willard Ave.
Sanh
Potte
Perki

Sanford Ave.
Russell
Robert Ave.
Ash St.
Marcus Whitman El. School
Hoffman St.
Levi
Jewett St.
Robin St.
Langfitt St.
McMurray St.
Swift St.
Newcomb
Black St.
Putnam St.

Lee
Thayer

Columbia Senior H.S.

Blvd.

St.

Blvd.

Davenport St.
Elder St.
Gillespie St.
Marshall St.

700 Area

Hadley Hospital

Lewis & Clark El. School

Gillmore Ave.
Goethals

Barth Ave.
Atkins Ave.
Armistead Ave.
Abert Ave.

Bowling St.
Andrews St.
Finley St.

George Washington Way

to Pasco

Columbia R

A House

66

E House

F House

Gustav Pehrson, a Spokane-based architect, was given three months to create a planned community to house workers on the Hanford Site. The government requested only basic accommodations, but DuPont insisted on quality construction, tree-lined streets, and spacious yards. Streets were purposefully laid out with curves rather than the typical gridded fashion. Several house styles were designed and designated with letters of the alphabet; three examples are shown.

Single Family House
TYPE D UNIT

BEDROOM #3 BEDROOM #4

DINING BEDROOM #1
KITCHEN
LIVING BEDROOM #2

Known as "Alphabet Houses," different designs were designated by letters of the alphabet. Only eight versions were constructed during the Manhattan Project: A, B, D, E, F, G, H, and L. Shown are plans for a D House. Each Alphabet House had a hand-fired coal furnace, laundry, and storage in the basement. (Courtesy of C.K. Anderson, helveticka.)

Dozens of versions of each home were built, and homes of the same letter were virtually indistinguishable from one another when they were newly built. Stories abound of husbands coming home to furniture they did not recognize and wives they were not married to—only to realize that they had actually entered a neighbor's house. (Courtesy of US Department of Energy Declassified Document Retrieval System.)

As the architect of the new Richland Village, Gustav Pehrson designed the town to incorporate the contours of the land and accentuate the sweeping views of the nearby hills. The impression of normalcy was a carefully cultivated image, but the clean and presentable city that Colonel Matthias insisted on, with spacious yards and pleasant views, was one where counterintelligence agents kept tabs on residents. (Courtesy of US Department of Energy Declassified Document Retrieval System.)

Background investigations were conducted, local police had copies of the key for every house in town, photographs required the approval of the area manager, phone lines were tapped for evidence of "loose talk," and outgoing mail was checked. Even the phone book was stamped as "classified." Only HEW employees were allowed to live in Richland. (Courtesy of US Department of Energy Declassified Document Retrieval System.)

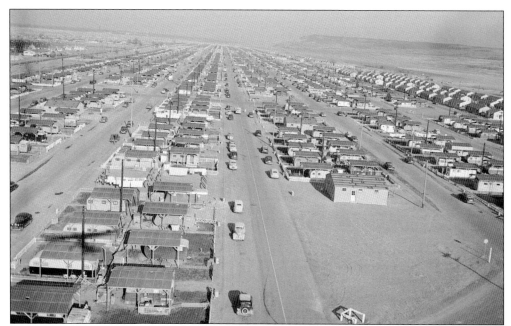

In 1947, shortly after the end of World War II, a construction boom fueled by the Cold War and renewed interest in plutonium production created a new housing shortage in Richland. A trailer park was established in North Richland to provide housing for a new influx of workers. Above is a view of the trailer park looking north toward the bluffs along the east side of the Columbia River. Richland continued grow at a record rate, and by 1950, there were almost 22,000 residents living in a town that had held only 247 a mere eight years earlier. (Both, courtesy of CJP.)

Even with the new trailer park in North Richland, there was a severe lack of living space in Richland in the late 1940s. The shutdown and dismantlement of the Hanford Construction Camp provided a temporary solution through the relocation of barracks to Richland via tractor trailers. To further ease the ongoing housing shortage, 46 barracks and a navy hospital building were moved to Richland after the Pasco Naval Air Station was closed in 1947. River barges were used to transport the barracks since Pasco was located across the Columbia River from Richland. This photograph shows how the barges were used to float the barracks across the river to where they would house Hanford workers. In late 1947, the *Richland Villager*, Richland's weekly newspaper, reported that Richland was the site of the "most intense construction activity and population growth of the entire Hanford Works expansion program." (Courtesy of CJP.)

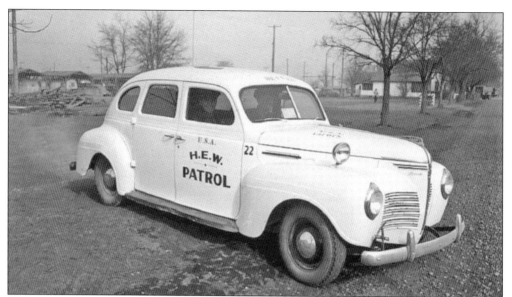

In the midst of what, just months before, had been nothing but desert, asparagus fields, and apple orchards, the Hanford Construction Camp was a raucous place where security forces spent as much time fighting gambling, prostitution, and rampant drunkenness as they did looking for spies. Even General Groves had to admit that it was a far-from-ideal situation. (Courtesy of US Department of Energy Declassified Document Retrieval System.)

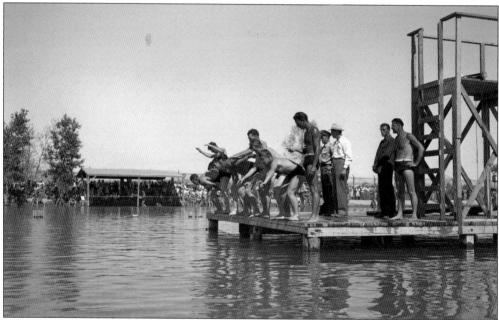

First came the tents in 1943, then the hutments, trailers, and barracks, and eventually the niceties of small-town American life, including stores, banks, medical facilities, movie theaters, schools, churches, taverns, a baseball field, and even a swimming hole (nicknamed Lake Hanford). At its peak in 1944, Hanford Construction Camp was home to 50,000 people, making it the fourth-largest city in the state of Washington. (Courtesy of US Department of Energy Declassified Document Retrieval System.)

Routinely asked to buy war bonds, HEW workers were surrounded by signs with the following propaganda: "Buy War Bonds Now—Help Bring Your Department to the Top," "These Weapons Were Used by our Enemy to Kill Americans," and "Our Boys Are In A Frontline Fighting Job—They Will Stay on That Job To the Finish–We At Hanford Are in a Front Line Working Job." (Courtesy of US Department of Energy Declassified Document Retrieval System.)

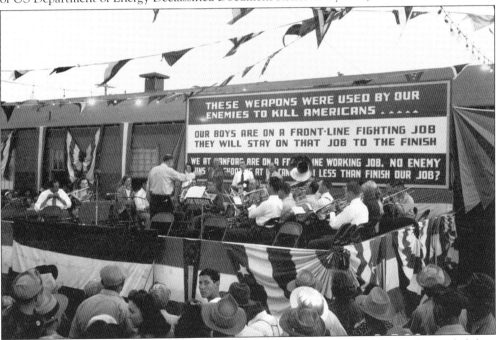

HEW employees willingly bought war bonds through payroll deductions and had exceeded their quota in the fifth bond drive. Due to the secrecy of the work at Hanford, the purchase of war bonds was one concrete way workers could knowingly contribute to the war effort. D-Day in Europe, June 6, 1944, was the inspiration to give more. (Courtesy of US Department of Energy Declassified Document Retrieval System.)

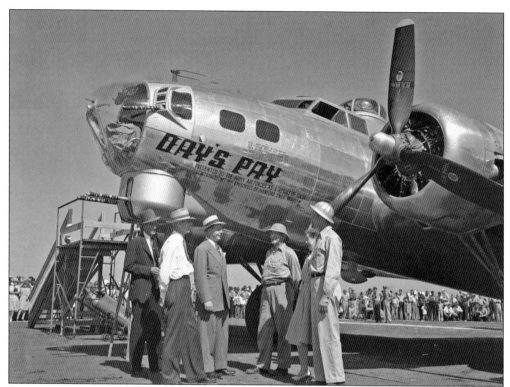

Carol B. Roberts related the events surrounding a "Day's Pay" in a B Reactor Museum Association newsletter (April 2001). "A carpenter crew at the B Reactor site wanted to do something to commemorate D-Day, but what? Someone suggested that something more tangible than war bonds was needed. Like a B-17 bomber?' suggested one of the carpenters. The idea caught the imaginations of the other 51,000 employees and $300,000 was raised to purchase the plane." (Courtesy of US Department of Energy Declassified Document Retrieval System.)

Roberts continues, "On Sunday July 23, 1944, a crowd of workers and their families stood at the Hanford airport in over 100-degree heat awaiting the arrival of their bomber. A contest had resulted in naming the plane a 'Day's Pay'." The Flying Fortress became a symbol of victory for the Allies. (Courtesy of US Department of Energy Declassified Document Retrieval System.)

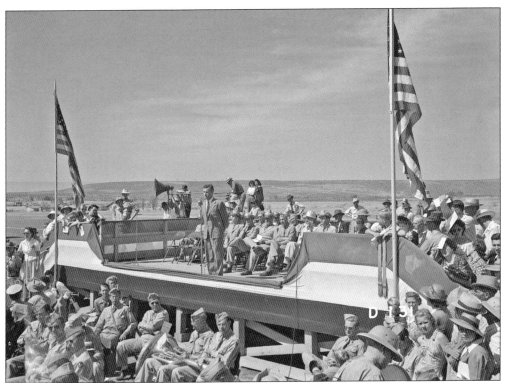

Thousands of workers attended a dedication ceremony at the small airfield near the Hanford Construction Camp. Kate Harris, an HEW employee whose son had been lost in action over Germany just months before, broke a bottle of champagne over the ship's nose. The crowd was jubilant and proud. This was their plane, a tangible contribution to the ongoing war effort. (Courtesy of US Department of Energy Declassified Document Retrieval System.)

As the plane took off, Roberts recalled, "It tipped its sunlit wings in a silent salute and silence fell over the crowd as it watched spell bound, until the plane could no longer be seen or the sounds of its motors heard." (Courtesy of US Department of Energy Declassified Document Retrieval System.)

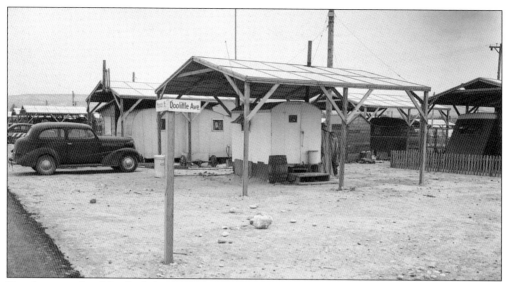

People arrived at Hanford dreaming of Washington's "famed evergreen forests" only to find themselves in an isolated area under rugged conditions with few amenities of normal life. Work was hard; the loneliness was palpable. Depression and homesickness were common. But just as the early settlers aimed to carve a hardscrabble living out of the sandy desert soil, Hanford Construction Camp residents made do. (Courtesy of US Department of Energy Declassified Document Retrieval System.)

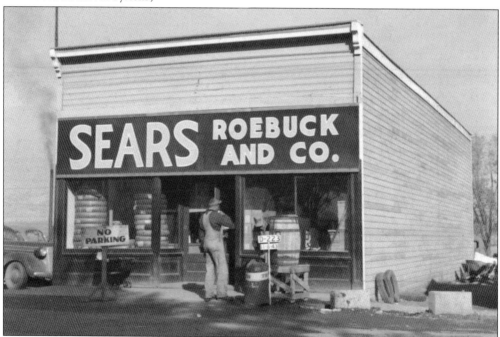

It was not a perfect community, but it was theirs. In less than two years, nearly 1,200 buildings—most of them living quarters of some sort—were constructed to accommodate the more than 137,000 people who were hired over the duration of the construction phase at Hanford. The Sears, Roebuck & Company store gave families a chance to purchase items for their homes. (Courtesy of US Department of Energy Declassified Document Retrieval System.)

Bathhouses were spaced at regular intervals throughout the trailer camp. In addition to showers and restrooms, the bathhouses also contained laundry facilities, with rows of irons, washboards, and large tubs, as well as a community clothesline. Ice tickets were available for purchase to cool food, as was lumber and paint to improve the lots. (Courtesy of US Department of Energy Declassified Document Retrieval System.)

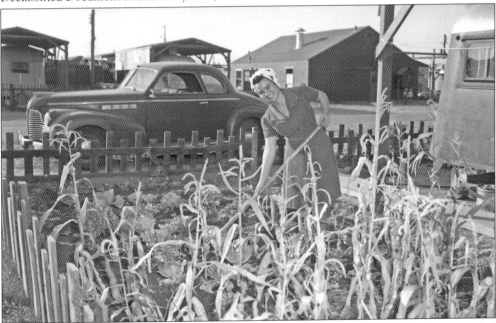

The camp, like the entire area, was systematically laid out. Row upon row of trailers extended as far as the eye could see. Aerial canopies were installed over the trailers, and there was even a children's playground. Some of the more creative residents planted rows of vegetables or flower gardens as an attempt to create normalcy where none existed. (Courtesy of US Department of Energy Declassified Document Retrieval System.)

D 802

D 5449

Manpower shortages and harsh living conditions led to high turnover and difficulty in recruiting laborers for the massive Hanford construction project. Much was done at the Hanford Construction Camp to entertain and retain workers. Dances and orchestra performances were a popular diversion from the unpleasantness of construction camp life. Above is one of the many dances typically held in the mess halls and often accompanied by big-name bands and orchestras. At left is a singer with the Jan Garber Orchestra, which played at the Hanford Construction Camp in July 1944. (Both, courtesy of US Department of Energy Declassified Document Retrieval System.)

D 7428

Holidays were particularly difficult for the workers living at the construction camp without their families. As Jane Hutchins, a secretary at the Hanford Site, recalled during an interview with the Atomic Heritage Foundation, "Our first Christmas, in '43, was rough, being away from home. I remember we planned a great big office party but there were no such things as Christmas trees, so some of us went out into the desert and got a big hunk of sagebrush." For churches, Hanford Engineer Works provided two standard army chapels—one for Protestants and one for Catholics. Each held its first service on Christmas Eve 1944. As a counterpoint, a successful chain reaction "going critical" was achieved when the first irradiated slugs were discharged from B Reactor on Christmas Day 1944. (Both, courtesy of US Department of Energy Declassified Document Retrieval System.)

Our token of APPRECIATION

For Your Swell Job at H.E.W.

This Christmas Dinner is Served in Appreciation of Your Contribution to The Project.

With the Compliments of
All Project Contractors and
The United States Army Engineers

DECEMBER 25, 1944

According to information provided by Christ the King Church archives, Catholics in the original communities around the HEW depended on services provided by the Kennewick parish. Fr. William J. Sweeney was the priest. The government gave the Kennewick parish permission to continue using the existing Lady of the Rosary Parish at White Bluffs for services. (Courtesy of CJP.)

Beginning in July 1943, Mass was celebrated every Sunday in White Bluffs for the construction workers. Because of the rapidly increasing attendance, Catholic services were transferred in August from White Bluffs to a tent at the Hanford Construction Camp being built at the old town of Hanford, according to Christ the King Church archives. (Courtesy of US Department of Energy Declassified Document Retrieval System.)

Planners wanted Richland Village to appear as a normal town, but security played a critical role in the life of its residents. Although no security fence was installed, residents were closely watched by counterintelligence agents, and the village police kept a copy of a key to every house in town. (Courtesy of US Department of Energy Declassified Document Retrieval System.)

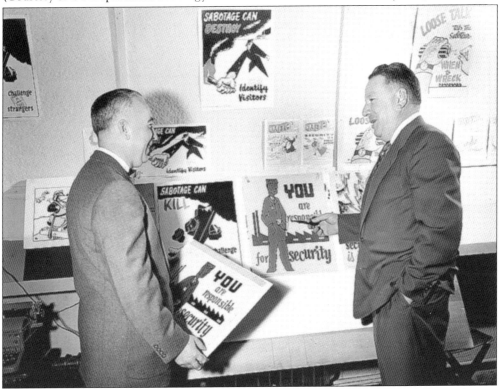

Mail was examined to ensure no sensitive information was being communicated out of town. Phones were tapped to listen for a breach of security or loose talk. Photographs could not be commercially sold or published without approval of the area manager. Even the phone book was classified. Signs posted around Richland reminded everyone of the rules. (Courtesy of US Department of Energy Declassified Document Retrieval System.)

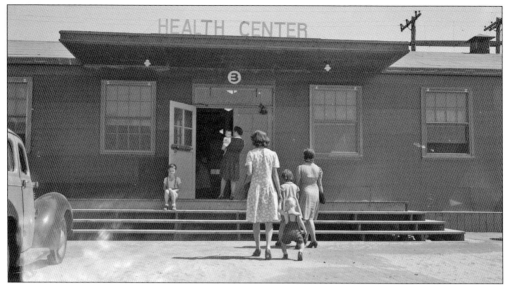

As stated in *Kadlec History, The Early Years*, "As Richland Village grew daily with people coming to work at Hanford, so did the need for adequate medical care. Its isolated location away from what were small and already overburdened area hospitals, not to mention the hazardous work under way, dramatically increased the need for a hospital in Richland." (Courtesy of US Department of Energy Declassified Document Retrieval System.)

Kadlec History, The Early Years states, "In early 1943, the first medical facility to serve those working at Hanford Engineer Works was established in an existing farmhouse at Hanford. In June 1943, the first aid equipment and staff were moved to one of the women's barracks at Hanford, where accommodations were provided for a 10-bed treatment area." (Courtesy of US Department of Energy Declassified Document Retrieval System.)

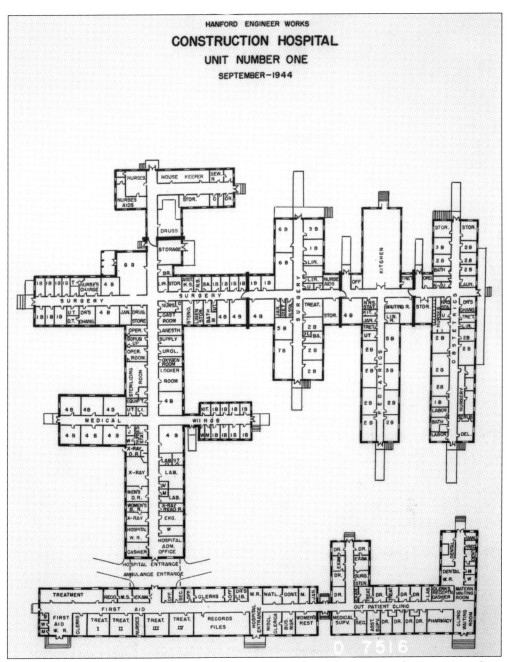

Kadlec History, The Early Years states, "The hospital was a closed facility, providing services only to Hanford workers, their families, and other citizens within the government-controlled boundaries of Richland. Plans for a one-story, 55,000-square-foot medical facility began in January 1944. It was a traditional army facility, with a central hall and wings expanding off the hall. In 1944, hospital personnel included the superintendent, assistant superintendent, part-time surgeon, two doctors, five nurses, and pharmacist. All medical services for the village were expected to be met by this medical force." (Courtesy of US Department of Energy Declassified Document Retrieval System.)

In addition to a lack of personnel when it opened, the hospital space itself proved inadequate to handle the medical needs of the new community. Routine medical care was practically on an emergency-only basis, although there was a venereal disease (VD) clinic as well as a significant focus on immunization. Posters were plastered everywhere to encourage families to vaccinate their children. (Courtesy of US Department of Energy Declassified Document Retrieval System.)

Kadlec History, The Early Years states, "By July 1, 1945, the total number of hospital employees had risen to 117. The new hospital had 91 rooms that could hold 115 patients. There was no room for outpatient care, dental care, and other services, so a medical-dental building was started near the hospital, and two houses provided 20 isolation beds as needed." (Courtesy of US Department of Energy Declassified Document Retrieval System.)

According to *Kadlec History, The Early Years*, "Enlargement of the maternity wing began even before the new hospital opened. The original design had one delivery room, six patient beds, and six nursery bassinets. Later, 22 bassinets and 30 cribs were added. In 1946, Richland led the nation's birthrate, with 35 births per 1,000 compared to a national average of 20 births per 1,000." (Courtesy of US Department of Energy Declassified Document Retrieval System.)

In *Kadlec History, The Early Years*: "As one report from the time states, 'The Security program of the plant dampened social activities, which perhaps served to encourage more pregnancy.' The actual number of babies born was a military secret; the numbers were not released to the public because of a concern that population experts from Germany and Japan would be clued in as to the size of the Hanford workforce." (Courtesy of US Department of Energy Declassified Document Retrieval System.)

THESE WEAPONS WERE L
ENEMIES TO KILL AMERI

OUR BOYS ARE ON A FRONT-LIN
THEY WILL STAY ON THAT JO

WE AT HANFORD ARE ON A FR INE WORI
INS SHOP G AT CAN LESS T

KADLEC PLAZA
DEDICATED IN MEMORY O
Lt. Col. Harry R. K

05680

During its first year, Kadlec Hospital served 3,153 patients. One of the hospital's first patients was Lt. Col. Harry R. Kadlec, deputy area engineer and chief of construction for the US Army Corps of Engineers at Hanford and a key figure in the operation of the project. Lieutenant Colonel Kadlec was said to have literally worked himself to death. He suffered a heart attack on July 2, 1944, and subsequently died at the hospital that was to bear his name. His was the first death in the new facility. Upon his death, flags at the Hanford area were lowered to half mast, and government workers were given time off to attend his services, which were held in the old Richland High School auditorium. On July 10, 1944, Richland Hospital was renamed Kadlec Hospital in honor of the late Lt. Col. Harry R. Kadlec. This photograph was taken at the dedication. (Courtesy of US Department of Energy Declassified Document Retrieval System.)

Nine

CONSTRUCTION OF SECRET FACILITIES

At the heart of Hanford was the B Reactor, a 36-foot-by-36-foot-by-28-foot reactor pile with 75,000 high-purity graphite blocks machined to exacting specifications and drilled to accommodate 2,004 process tubes. Each of the process tubes was loaded first with 16 aluminum spacers, then 32 uranium fuel slugs, followed by another 16 aluminum spacers; the tubes themselves were arranged in a pattern to create the ideal conditions necessary for sustaining a nuclear chain reaction within the reactor core. To contain radioactivity, the graphite pile was encased in two protective layers: first, a 10-inch-thick cast-iron thermal shield, and second, a 52-inch-thick biological shield consisting of alternating layers of steel and Masonite. The thermal shield absorbed and converted nearly 97 percent of the gamma energy produced during the fission process to heat, while the biological shield contained any fast neutrons that had escaped and passed through the thermal shield, slowing the neutrons and absorbing the released nuclear energy. The reactor block was then sealed in a welded steel box, inside which was an artificial atmosphere of circulated helium gas that prevented contamination of the neutrons and helped cool the graphite blocks.

B Reactor first went critical on September 26, 1944, producing plutonium on a production scale for the first time. Water entered the face of the reactor's moderator at 30,000 gallons per minute, going from 50 to 70 degrees Fahrenheit (depending on the season) up to 170 degrees by the time it exited the rear less than a second later. Discharged water was sent to retention basins to cool and allow any short-lived radionuclides, or radioactive isotopes, it picked up along the way to decay and stabilize. To complete the process, the warm water was pumped back into the river.

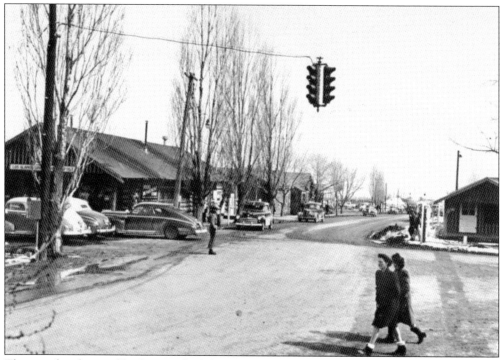

The main bomb assembly plant was built here at Los Alamos, New Mexico. J. Robert Oppenheimer was put in charge of putting the pieces together. Oppenheimer spent the first three months of 1943 tirelessly crisscrossing the country in an attempt to assemble a first-rate staff—an effort that proved highly successful.

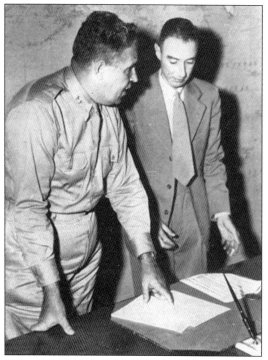

After Oppenheimer (right) arrived at Los Alamos in mid-March, recruits began arriving from universities across the United States, including California, Minnesota, Chicago, Princeton, Stanford, Purdue, Columbia, Iowa State, and the Massachusetts Institute of Technology, while still others came from the Metallurgical Laboratory and the National Bureau of Standards. Overnight, Los Alamos became an ivory-tower frontier boomtown with scientists and their families, along with nuclear physics equipment.

In 1942, General Groves approved what became the Clinton Engineer Works, about 25 miles west of Knoxville, as the site for the pilot plutonium plant and the uranium enrichment plant. Engineers of the Manhattan Project had to quickly establish a town to accommodate 30,000 workers, as well as build the enormously complex plants. The S-50 plant is shown along the banks of the Clinton River.

The 59,000 acres in eastern Tennessee was known as Site X. In 1943, Oak Ridge was chosen as the name for the settlement from among the suggestions submitted by project employees. The name related to the settlement's location along Black Oak Ridge, and officials thought the rural-sounding name "held outside curiosity to a minimum." The name was not formally adopted until 1949.

The K-25 (pictured), S-50, and Y-12 plants were each built in Oak Ridge to separate the fissile isotope uranium-235 from natural uranium. During construction of the magnets, which were required for the process that would separate the uranium at the Y-12 site, a shortage of copper required borrowing 14,700 tons of silver bullion from the US Treasury as a substitute.

The X-10 site was established as a pilot plant for production of plutonium using an air-cooled graphite reactor. Shown are workers loading uranium fuel into the front face of the X-10 reactor. The residents of the town of Oak Ridge, just 20 miles away, had absolutely no idea of what was to come.

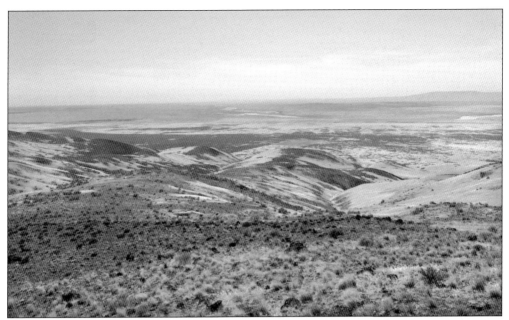

Site W, the code name for Hanford Engineer Works, was 670 square miles of remote desert in southeastern Washington state. The nearest rail station was located in Pasco, roughly 15 miles from what became the fuel manufacturing area of the site. Though a number of small agricultural communities dotted the area, including the busy townships of Hanford and White Bluffs, the total population was just over 2,000 settlers.

An essential component of the plutonium production process was a steady supply of pure cold water for cooling the piles. Furthermore, the proximity of two major dams, Grand Coulee and Bonneville, meant an abundance of reliable, inexpensive electricity. The Midway Substation shown here was built near Vernita, Washington.

After the decision was made to produce plutonium, the government needed to draw upon the talent and resources of corporate America to get the job done. General Groves was familiar with the E.I. du Pont de Nemours and Company, the major chemical and munitions company founded by Éleuthère Irénée du Pont (pictured) in 1802.

DuPont's manufacturing history and capabilities were impressive. When the US Army Corps of Engineers first approached DuPont to design, engineer, construct, equip, train, and operate Hanford Engineer Works, the company was naturally reluctant. But General Groves told DuPont executives that it had to be done. (Courtesy of US Department of Energy Declassified Document Retrieval System.)

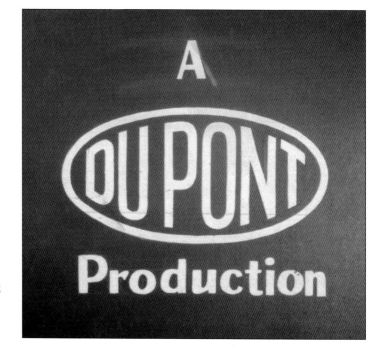

The War Department believed that the Germans were likely working on their own atomic weapons program and suspected Werner Heisenberg (pictured) was involved. An atomic bomb in US hands would shorten the war and save lives. Despite Groves's urging, it took a call from President Roosevelt to convince DuPont's president to sign up for this uncertain venture.

·LIFE·
March 10, 1919
page 349

Profiteer: THE WAR IS OVER, MY BOY. FORGET IT!

DuPont did not want to be branded as "war profiteers," as they had been after World War I, not to mention the fact that no project like this had ever been conceived or executed and there was no room or time for error. DuPont insisted that its fee would only be $1, plus costs, and all patents would belong to the US government.

DuPont's managers knew that mass-producing plutonium would be unlike any challenge they had previously faced. Enrico Fermi's experimental reactor in Chicago, which achieved the first self-sustained chain nuclear reaction in December 1942, had to be scaled up a million times—as quickly as possible and with the utmost of secrecy.

CONTROL RODS (36)

WATER ANNULUS

ALUMINUM TUBE

URANIUM METAL

ALUMINUM JACKET

DETAIL OF TUBE

GRAPHITE

ALUMINUM TUBES CONTAINING URANIUM SLUGS

~36'

~36'

~28'

APPROXIMATE WEIGHT OF METAL IN PILE= 200 TONS

APPROXIMATE WEIGHT OF GRAPHITE IN PILE= 1600 TONS

Many technical questions, from how to cool the reactor to how to safely extract plutonium from the spent fuel rods, remained unanswered. There was no time for rigorous testing or a long-term pilot-scale facility. DuPont engineers had to use their best judgment to choose an approach and make it work. Here, a cross section through the graphite core shows the arrangement of a process tube containing the uranium fuel.

The first major construction project was Hanford Camp, a temporary city designed and built to house the workers who would then turn their attention to the infrastructure required to convert a 125-pound uranium billet into an atomic weapon. This view of the construction camp is looking north, with Gable Mountain at left and the Columbia River at right. (Courtesy of US Department of Energy Declassified Document Retrieval System.)

Next came the operations: one fuel fabrication facility, three reactors, and three chemical separations plants. Deemed the least dangerous, fuel fabrication was placed closest to Richland. At the northernmost part of the site, the three reactors were installed six miles apart and roughly 30 miles from Richland, along the banks of the Columbia River. B Reactor is pictured here under construction. (Courtesy of US Department of Energy Declassified Document Retrieval System.)

Each of the three reactor areas (100 Area) was a mile square and entirely self-contained. Included, in addition to the reactor itself (4), was a pump house on the river (1), water treatment facilities (2), water storage and pressure facility (3), helium storage and purification building (5), fresh metal storage building (6), emergency water storage towers (7), chemical pump house (8), coal-fired steam plant (9), coal storage (10), and a fly ash basin (11). Not shown was a retention basin that held the discharged cooling water before it was returned to the river. Reactors the scale of those at Hanford had never been built before, yet the B Reactor, which began construction in 1943, was producing plutonium by November 1944. The very idea of producing plutonium in sufficient quantities to build a super weapon capable of leveling an entire city would have been science fiction to just about everyone on-site, with the exception of the theoretical physicists. (Courtesy of US Department of Energy Declassified Document Retrieval System.)

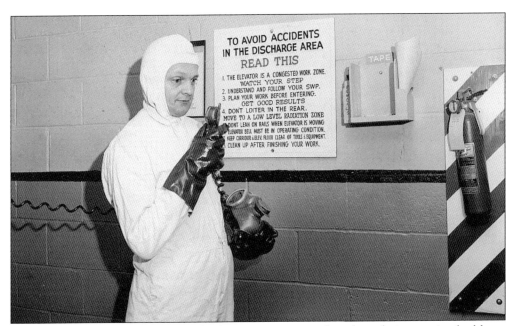

Enrico Fermi's Chicago Pile-1 was the first time a sustained nuclear chain reaction had been achieved; if B Reactor was successful, it would be the first full-scale nuclear reactor in human history. The obvious question, then, concerned safety: Were people aware of the potential dangers of a process that had never been done before? (Courtesy of US Department of Energy Declassified Document Retrieval System.)

Workers were provided with pencil dosimeters and protective clothing. Five feet of concrete stood between crane operators and radioactive sludge in the separations plants, and time of exposure was limited to assure worker health and safety. Dosimeters were read daily, and workers were limited to a maximum exposure level each month. (Courtesy of US Department of Energy Declassified Document Retrieval System.)

There's a Job for You at **Hanford**

Life here is a little on the rugged side, but you'll find lots of conveniences you wouldn't expect in a construction camp. We've tried to set down honestly the facts – or highlights – of Hanford in the Answers to the questions in this booklet. If can fill the bill, we'll welcome you on the job, because we need you to help us bring the day of Victory nearer.

E. I. du Pont de Nemours and Company, Incorporated, is the prime contractor.

◄ **Hanford Mess Halls are famous for their good pies.**

Finding both skilled and unskilled laborers for the Hanford Site was a challenge. Because of the war, most able-bodied men, 38 years of age or younger, had already been drafted. DuPont recruiters were sent to all 48 states, as well as Alaska and Canada, to encourage skilled craftsmen to come to Hanford, Washington. And once workers were hired, retaining them was not easy. The turnover rate was blamed on isolation, living conditions, and secrecy requirements, not to mention that Hanford was not viewed as being vital to the war effort. At the peak of employment, there were about 50,000 workers at Hanford, but more than 130,000 workers had to be hired due to the high turnover rate. (Both, courtesy of US Department of Energy Declassified Document Retrieval System.)

D 1966

Plumbers, steamfitters, electricians, bricklayers, and lead burners were all needed. Advertising Hanford only as a "Pacific Northwest Construction Project," recruiters were modest in their descriptions. "There's a job for you at Hanford," one pamphlet stated. "It's not a short job and it's not a small job. We can't tell you much about it because it's an important war job, but we can tell you that it's new heavy industrial plant construction." Workers arrived from all 48 states at the time; many arrived without their family, knowing that the job would only last a few years. Those who stayed accomplished an amazing feat and contributed to the birth of the Atomic Age. (Courtesy of US Department of Energy Declassified Document Retrieval System.)

Here, work is being done on the B Reactor core in February 1944. The base and shield was completed by mid-May. It took another month to place the graphite pile and install the top shield and two more months to wire and pipe the pile and install monitoring and control devices. (Courtesy of US Department of Energy Declassified Document Retrieval System.)

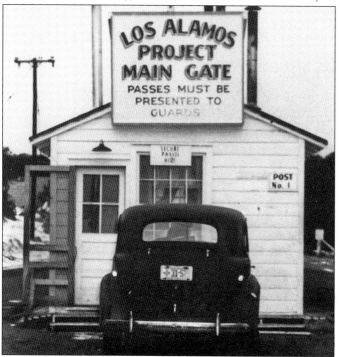

Success was achieved when the first irradiated slugs were discharged from the B Reactor on Christmas Day 1944. The irradiated slugs were shipped to the chemical-processing facilities. In January 1945, the highly purified plutonium underwent further concentration in the completed chemical isolation building, where remaining impurities were successfully removed. Los Alamos received its first plutonium shipment on February 2, 1945.

The following is another excerpt from "Robley Johnson Remembers," an interview conducted by Ted Van Arsdol in 1991: "One day they said they wanted some pictures of this graphite being laid, because it was milled to real close tolerances and had to be put into a certain way. So I had about four passes to get up there. With all this secrecy and the importance of what you were doing, it was just drummed into you 24 hours a day until finally, here I was on the top of this building, looking down into the bowels of this pile as it was being formed. I was right up there, and all these men down in there. They were dressed in white coveralls and white shoe covers. They had vacuum cleaners because you couldn't have the slightest speck of dust in there. I thought I was standing on holy ground." (Both, courtesy of US Department of Energy Declassified Document Retrieval System.)

The plutonium production process required three steps: fuel manufacturing (300 Area), fuel irradiation (100 Area), and plutonium separation (200 Area). Keenly aware of the possibility of explosions of catastrophic proportions, Hanford planners assigned each of these steps to self-contained, semiautonomous units, then put several miles of desert and sagebrush between them. In the 300 Area, adjacent to Richland Village, fabricated fuel slugs were placed on a train and sent to the 100 Area, located as far as possible from Richland, to load into the reactors. Once physicists determined that enough slugs were properly irradiated, an outage was scheduled and the reactor was shut down. The fuel would be discharged into a basin of water and held for approximately 90 days. Spent fuel was then shipped by rail to the chemical separation plants located about 7–10 miles south of the reactors.

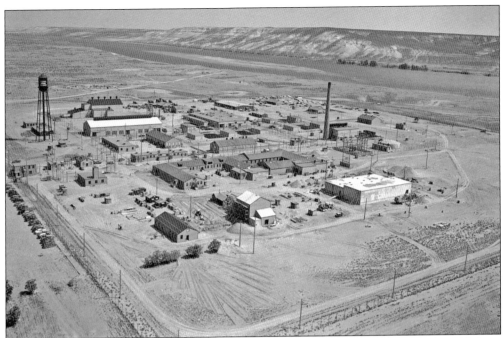

The fuel production cycle began with natural uranium metal, which arrived at the 300 Area (pictured) under armed guard. After inspection and testing, the uranium was heated, extruded, and outgassed to remove hydrogen, then cut into slugs and machined to precise tolerances of 8 inches long and 1.336 inches in diameter. (Courtesy of US Department of Energy Declassified Document Retrieval System.)

Workers bathed the slugs in molten bronze, then tin, and finally an aluminum-silicon mixture. The final step was "canning" in which each slug was encased in a thin coating of aluminum to seal out water and allow for optimal heat transfer. Slugs that passed additional testing were sent to the reactors to be irradiated to transmute uranium into plutonium. (Courtesy of US Department of Energy Declassified Document Retrieval System.)

After irradiation in the reactors, workers discharged the fuel elements into a 20-foot-deep pool of water. The fuel was placed into buckets, then moved to a storage area to cool for approximately 30 days. After cooling, the buckets were loaded into casks and placed by crane into lead-shielded railroad cars for shipment to the 200 Area. (Courtesy of US Department of Energy Declassified Document Retrieval System.)

Both 221T (pictured) and 221U, the chemical separation buildings in the 200-West complex, had been finished by December 1944. Their counterpart in 200-East, 221B, was completed in the spring of 1945. Nicknamed "Queen Marys" by the workers who built them, the separation buildings were canyon-like structures measuring 800 feet long, 65 feet wide, and 80 feet high. (Courtesy of US Department of Energy Declassified Document Retrieval System.)

The interior of the separation facilities had an eerie quality as operators, behind thick concrete shielding, manipulated remote control equipment by looking through television monitors and periscopes from an upper gallery. Even with massive concrete lids on the process pools, precautions against radiation exposure were necessary and influenced all aspects of plant design. (Courtesy of US Department of Energy Declassified Document Retrieval System.)

Construction of the chemical concentration buildings was a less daunting task because relatively little radioactivity was involved. In January 1945, Colonel Matthias personally couriered the first batch of plutonium nitrate to Los Angeles, where he handed it over to another courier, who took it to Los Alamos to be fashioned into an atomic bomb. Pictured here is building 224-T. (Courtesy of US Department of Energy Declassified Document Retrieval System.)

The nearly 900-foot-long T Plant was the first of Hanford's chemical separations facilities. Irradiation in the reactors would transmute atoms in the uranium slugs, literally changing them from one element to another. Although it was still a solid cylinder of metal, each slug had a new atomic composition: it now contained plutonium. (Courtesy of US Department of Energy Declassified Document Retrieval System.)

In the 200 Area, irradiated fuel went through a multistep chemical process that first dissolved the aluminum coating on the outside of the uranium fuel slug, then the spent fuel itself, separating the plutonium from the unconverted uranium and various fission by-products. What remained was a solution of plutonium nitrate. (Courtesy of US Department of Energy Declassified Document Retrieval System.)

Enrico Fermi's slide rule told him that a self-sustaining chain nuclear reaction was possible. And he proved it in 1942 when he used uranium as fuel in Chicago. With the discovery of highly fissionable plutonium-239 by Glenn Seaborg and his team at the University of California a year earlier, scientists now believed that there were at least two paths to an atomic bomb.

But which would be most effective? And more important, which could be built more quickly? General Groves was not a gambling man. He assigned the task of enriching uranium to the facilities at Oak Ridge, Tennessee, and the production of plutonium to Hanford Engineer Works. Shown here are calutron operators at the Y-12 plant in Oak Ridge, Tennessee.

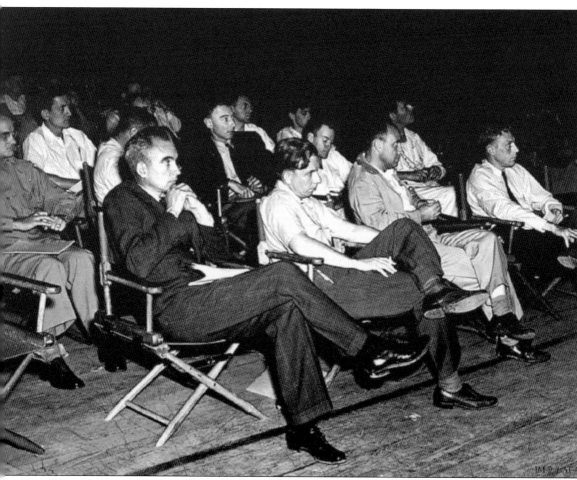

General Groves told the scientists at Los Alamos, New Mexico, to figure out how to turn each of these fuels into a working bomb. That way, Groves figured, at least one of the paths was bound to lead to success. Physicists, chemists, metallurgists, explosive experts, and military personnel converged on the isolated plateau. At times, six Nobel Prize winners gathered with the other scientists and engineers in the weekly colloquiums put on by Robert Oppenheimer. Shown above are, from left to right, (first row) Norris Bradbury, John Manley, Enrico Fermi, and J.M.B. Kellogg; (second row) Col. Oliver G. Haywood, unidentified, J. Robert Oppenheimer, Richard Feynman, and Phil B. Porter. Scientists carried out experiments in metallurgy and high explosives. They scribbled mathematical calculations on chalkboards and cocktail napkins. They worked 10- and 12-hour days, six days a week, then sipped famously potent martinis at Oppenheimer's home and played musical concerts in Fuller Lodge for relaxation.

Ten

SCIENTISTS AND THEIR SCIENCE

American physicist Luis Alvarez designed the detonators used in both the Trinity test bomb and the Nagasaki bomb. Enrico Fermi, who escaped Fascist Italy in 1938, and Hungarian physicist Leó Szilárd designed Chicago Pile-1 in 1942. Hanford technical director Crawford Greenewalt served as liaison between the physicists at the Chicago Metallurgical Laboratory and the DuPont engineers working on the B Reactor. At Los Alamos, chemist Donald Horning created the trigger mechanism used for the implosion device for both the Trinity test bomb and the Fat Man bomb. Leona Marshall Libby was the only woman present at the Chicago Pile-1 and B Reactor when they went critical. With her nephew Otto Frisch, Lise Meitner published a paper on fission in 1939. Theoretical physicist J. Robert Oppenheimer was the director of the Los Alamos laboratory. John A. Wheeler collaborated with Niels Bohr in 1939 to develop the first general theory of the mechanism of fission. Wheeler was Hanford's leading physicist. Eugene Wigner was responsible for the design of the world's first full-scale plutonium production reactors—B, D, and F at Hanford.

It is remarkable that the atomic bomb was built in time for World War II. Most of the theoretical breakthroughs in nuclear physics dated back less than 25 years, such as Lise Meitner (left) and Otto Hahn's (right) groundbreaking work on transuranic elements. Many fundamental concepts in nuclear physics and chemistry had yet to be confined by laboratory experimentation.

Initially, there was no conception of the design and engineering difficulties that would be encountered in translating what was known theoretically into working devices capable of releasing the enormous energy of the atomic nucleus in a predictable fashion. Below, Leó Szilárd laid the groundwork for reactor design and had even filed a patent for how to generate a nuclear chain reaction in 1936.

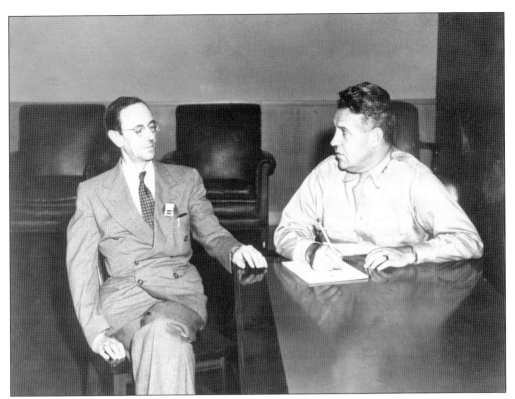

The Manhattan Project was as much a triumph of engineering as of science. Without the innovative leadership of General Groves, the revolutionary breakthroughs achieved in nuclear science would not have produced the atomic bomb during World War II. Above, Groves (right) is shown with James Chadwick, an English physicist who was instrumental in writing the MAUD Report, which helped propel the United States into the Atomic Age.

The United States was able to combine the forces of science, government, military, and industry into an organization that took nuclear physics from the laboratory and into battle with a weapon capable of mass destruction. Fermi (center) engages the great minds of Ernest O. Lawrence (left) and Isidor Rabi (right) while at Los Alamos.

Albert Einstein's $E=mc^2$ is perhaps the most famous equation in the world—three simple letters that nearly everyone can recite by memory. When Einstein published this equation in 1905, the three entities were kinetic energy (E), mass (m), and time (represented by the speed of light, or c2). Einstein concluded that because the speed of light is constant, mass and energy are equal.

If Einstein was right, that meant that energy could be converted into mass. More importantly, it also meant that mass could be transformed into energy. While Einstein had nothing directly to do with the development of atomic weapons, it was $E=mc^2$ that proved that it just might be possible to build one. Fermi, right, is shown conferring with Einstein.

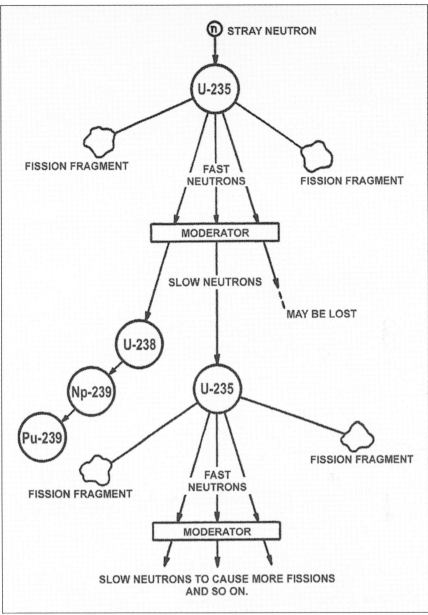

Plutonium is an artificially created element, only rarely existing in nature. This product of uranium transmutation and fission relies on the geometry of the nuclear fuel, the physics of the resulting chain reaction, and the chemistry behind the subsequent elemental transmutation. Under neutron bombardment within a nuclear reactor, uranium-235 atoms are split by free neutrons into two or more new atoms. Two or three more neutrons are released. A moderator slows down the newly released neutrons. Some of the free neutrons are lost, while others strike atoms of uranium-235, and the chain reaction continues. Other free neutrons, slowed by the moderator, are captured by atoms of uranium-238. The additional neutron changes the uranium-238 to uranium-239. Within minutes, the uranium-239 spontaneously decays into neptunium-239, a highly unstable element with a half-life of only 2.3 days. During radioactive decay, the neptunium-239 spontaneously decays into plutonium-239, a radioactive element with a 24,000-year half-life.

On July 16, 1945, the device was affixed to a 100-foot tower and discharged just before dawn. No one was properly prepared for the result. A blinding flash visible for 200 miles lit up the morning sky. A mushroom cloud reached 40,000 feet, blowing out windows of civilian homes up to 100 miles away.

After the Trinity test, a bogus cover-up story was quickly released, explaining that a huge ammunition dump had exploded in the desert. Soon, word of the project's success reached President Truman in Potsdam, Germany. J. Robert Oppenheimer (third from left) and Gen. Leslie Groves (fourth from left), along with other officials, examine the remains of the Trinity shot tower.

Seconds after the Trinity explosion came a huge blast, sending searing heat across the desert. Standing a half mile from ground zero, a steel container weighing over 200 tons was knocked ajar. The container, nicknamed "Jumbo," had been ordered for the plutonium test and transported to the test site but eliminated during final planning.

The searing heat of the Trinity explosion melted the sandy soil around the tower to form a glassy crust known as "trinitite." Years later, with a view toward making the Trinity site a tourist-accessible national historic site, the mildly radioactive crust was bulldozed into heaps and covered with soil. (Courtesy of Lucas W. Hixson, "The Trinitite Project.")

Located near the Alamogordo Bombing Range, the Trinity Base Camp was built by the Army in the winter of 1944 and was occupied by a detachment of military police from that December on. By summer, it had become a bustling hive of activity with more than 200 scientists, soldiers, and technicians. Shortly after the Trinity blast, the camp was dismantled.

Here is an aerial view of the aftermath of the Trinity test, the success of which meant that a second type of atomic bomb could be readied for use against Japan. Oppenheimer reported that the experience called to mind the legend of Prometheus, punished by Zeus for giving man fire. He also thought fleetingly of Alfred Nobel's vain hope that dynamite would end wars.

EXTRA | The Villager | EXTRA

VOLUME 1 Richland, Washington, Monday, August 6, 1945 NUMBER 28-A

IT'S ATOMIC BOMBS

News Spreads Slowly, Surprises Everyone Here

Jubilation And Satisfaction Follows Revelation Of Product Manufactured Here

Richland was about the last place in the country to hear the news of the atomic bomb. As in other parts of the country it was the housewives who first heard the news over their radios, and broke it to their husbands in a flurry of telephone calls which kept the switchboards humming.

In town, the stores were all closed until noon and few people were on the street. It was THE VILLAGER reporter who spread the word to most of those encountered. Disbelief was soon followed by enthusiasm. Everyone felt the same reaction—"It's nice to know what this project is all about" and "May be the war will end promptly."

To nearly everyone the news of what Richland was helping to make came as a complete surprise. Even those who may have been in the know would not admit it. The old habit of secrecy was strong upon them.

Said J. T. Minard who was downtown doing some shopping: "They did the most marvelous job of keeping a secret. I just didn't think it would be possible."

Patrolman W. N. Gasway, who a Japanese military secret.

Development Of Bomb Traced

Begun In 1939; Plant Expanded In June, 1942

The energy of the atom has been harnessed to produce the deadliest weapon ever devised, the atomic bomb, the War Department today announced shortly after the first of the aerial missiles crashed upon

President Truman Releases Secret of Hanford Product Information Is Made Public This Morning

SPECIAL—Today President Truman in an official White House release

The Trinity test, held in July 1945, was the world's first nuclear explosion. Less than a month later, on August 6, 1945, newspapers around the country and the world, including a special edition of the Richland *Villager* announced, "It's Atomic Bombs." Col. Paul Tibbets had dropped a uranium-fueled atomic bomb, nicknamed "Little Boy," over Hiroshima, Japan. With the announcement from President Truman, the nature of the work performed at Hanford became known. On August 9, Fat Man, the plutonium bomb whose material was produced at Hanford, was detonated over Nagasaki. Until then, less than one percent of the Hanford workers knew what they were working on. Most of the Hanford workers shared a sense of pride and satisfaction once they discovered their true contribution to the war effort. (Courtesy of Franklin County Historical Society.)

Five days after the bombing of Nagasaki, the Japanese emperor surrendered on August 15, 1945, bringing World War II to an end. Secretary of War Henry Stimson later declared that the two atomic bombs had saved a million American casualties that would have resulted from another secret plan, Operation Downfall, which was the proposed invasion of Japan had the emperor not surrendered. Foreign minister Mamoru Shigemitsu (wearing the top hat in the first row) and Gen. Yoshijiro Umezu, chief of the Army General Staff, are shown aboard the USS *Missouri* in Tokyo Bay on September 2, 1945, to sign the Japanese Instrument of Surrender. US general Douglas MacArthur accepted the formal surrender in his capacity as the supreme commander of the Allied Powers.

Conventional explosive

Gun barrel

Hollow uranium "bullet"

Cylinder target

Two types of atomic bombs were developed during the war. A relatively simple gun-type fission weapon, Little Boy was made using uranium-235, an isotope that makes up only 0.7 percent of natural uranium. The necessary enrichment of uranium for use in Little Boy was performed in Oak Ridge, Tennessee. (Courtesy of Vector Version by Dake with English labels by Papa Lima Whiskey, line modified by MField.)

In parallel, reactors were constructed at Oak Ridge, Tennessee, and Hanford, Washington, in which uranium was irradiated and transmuted into plutonium. The plutonium was then chemically separated from the uranium. The gun-type bomb design (pictured) proved impractical to use with plutonium, so an implosion-type weapon was developed at the project's principal research and design laboratory in Los Alamos, New Mexico.

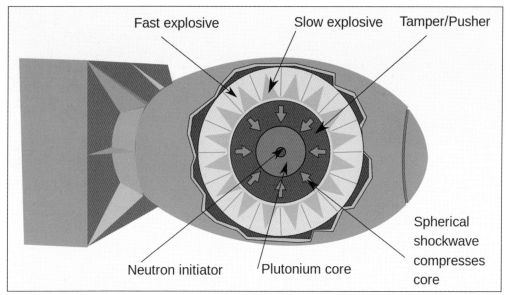

Fast explosive Slow explosive Tamper/Pusher

Spherical
shockwave
compresses
core

Neutron initiator Plutonium core

Fat Man, an implosion-type weapon utilizing plutonium as its fuel, was developed and used in the atomic bombing of Nagasaki on August 9, 1945. At 10 feet, 8 inches long, with a diameter of 60 inches, it was dubbed "Fat Man." Its swollen midsection contained about 13.6 pounds of plutonium-239 and gallium, surrounded by a uranium tamper. (Courtesy of Fast Fission, redrawn by Ausis.)

Upon firing of the high explosives that surrounded the inner sphere, the plutonium-gallium core was instantaneously compressed from the size of a softball to that of a tennis ball; at the same time, a beryllium-polonium initiator hit the core with a burst of neutrons, initiating the chain reaction that led to detonation.

The veil of secrecy that had hidden the atomic bomb project was lifted on August 6, 1945, followed by the release of the Smyth Report on August 12, 1945. Calculated to satisfy public curiosity without disclosing any atomic secrets, the report contained general technical information that brought the Manhattan Project into fuller view.

Full Text of the Official Report

ATOMIC ENERGY
FOR MILITARY PURPOSES

By HENRY D. SMYTH

A General Account of the Scientific Research and Technical Development That Went into the Making of Atomic Bombs

Americans were astounded to learn of the existence of a far-flung, government-run, top secret operation with a physical plant, payroll, and labor force comparable in size to the American automobile industry. At its peak, the project employed approximately 130,000 people, among them many of the nation's leading scientists and engineers.

According to an Atomic Heritage Foundation interview with Jane Jones Hutchins, "When they dropped the bomb; that was an exciting time. I had never heard of such a thing as atomic power. Right after that, the war ended. Well, I fought the war at Hanford. It seemed as if we were doing our bit. It was a lark, it was exciting. After they dropped the bombs and the war ended, I was out at the old Hanford Camp with Colonel Matthias. We watched some half-wild goats walking in front of the movie theater. The colonel turned to me and said, 'You know Jane, this is like going to your mother's funeral. This was a living, breathing place with a personality.'" From overhead, scars left on the landscape from the Hanford Construction Camp are still visible, such as the ghostlike marks where the rows of trailers were located.

Hanford photographer Robley Johnson summarizes his time at the site: "I've enjoyed my stay out here. It has been home to my family. My children have all gone through school here and my daughter was born here. I think's it's a great place. I like the area and enjoy my life here. I wouldn't have missed it for the world." (Courtesy of US Department of Energy Declassified Document Retrieval System.)

Johnson continues with his thoughts on the project: "I think it's the greatest undertaking that man has ever done, when you stop and think of the conditions: there was a war going on; manpower was at a premium; the people building the plant didn't know what they were doing. They were just doing what they were told. Time was of the essence. We had to beat Hitler." Pictured here is Johnson's photography studio in Richland, Washington. (Courtesy of CJP.)

During the Manhattan Project, many engineers contributed to ending the war and developing new technologies. Never had an industrial-scale nuclear reactor been built, and it took an international effort to succeed. Pictured from left to right are William Penney, Otto Frisch, Rudolf Peierls, and John Cockroft shortly after receiving the Medal of Freedom for their contribution to the Manhattan Project.

New technologies used to protect workers from radioactive contamination were developed at Hanford, such as an innovated modular cell concept, which allowed major components to be removed and replaced by an operator sitting in a heavily shielded overhead crane (left). As a result, two technologies would gain widespread use: Teflon and closed-circuit television. (Courtesy of US Department of Energy Declassified Document Retrieval System.)

In September 1946, the General Electric Company assumed management of Hanford Engineer Works under the supervision of the newly created Atomic Energy Commission. The United States faced a new strategic threat in the rise of the Soviet nuclear weapons program. This threat became known as the Cold War and extended over 40 years.

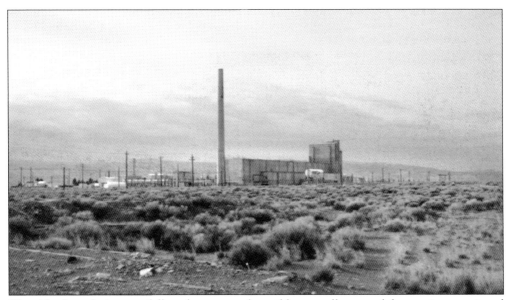

The risk of escalation to a full nuclear war and possible mutually assured destruction convinced the United States that plutonium production must continue. By August 1947, Hanford Engineer Works had announced funding for the construction of two more plutonium production reactors and for research leading to the development of a new chemical separations process facility known as REductionOXidation Plant (pictured).

Two other construction booms at the Hanford Site would soon follow, driven by fears of enemy nuclear weapons development. By 1963, the Hanford Site had become home to nine nuclear reactors along the Columbia River, five reprocessing plants on the central plateau, and more than 900 support buildings and radiological laboratories around the site. Extensive modifications were made to the original three World War II reactors, allowing for greater and greater power output and thus plutonium production. Chemical separation of plutonium from the spent uranium fuel generated a significant amount of radiological and hazardous chemical liquid waste. A total of 177 underground waste storage tanks were built—149 single-shelled tanks and 28 double-shelled tanks. Storage capacity of the underground tanks range from 50,000 to 1 million gallons. (Courtesy of US Department of Energy Declassified Document Retrieval System.)

After the last production reactor was shut down in 1987, the weapons production mission of Hanford was "reengineered" to one of cleanup. Billions of gallons of low-level liquid waste had been discarded directly into the soils, contaminating approximately 80 square miles of groundwater. Hundreds of solid waste burial grounds contain drums of chemicals, boxes of materials, and sometimes random items, such as tools and clothing. Decades of plutonium production also generated 56 million gallons of high-level radioactive and chemical waste, currently stored in single-shelled and double-shelled underground tanks. Now, the great minds must develop technologies that will protect the public, land, and waterways from some of the most dangerous materials ever developed by humankind. Shown above is the massive Hanford Tank Waste Treatment and Immobilization Plant (Vitrification Plant) currently under construction at the Hanford Site. And that is another story.

Discover Thousands of Local History Books Featuring Millions of Vintage Images

Arcadia Publishing, the leading local history publisher in the United States, is committed to making history accessible and meaningful through publishing books that celebrate and preserve the heritage of America's people and places.

Find more books like this at
www.arcadiapublishing.com

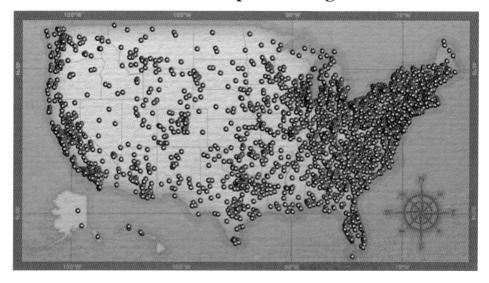

Search for your hometown history, your old stomping grounds, and even your favorite sports team.